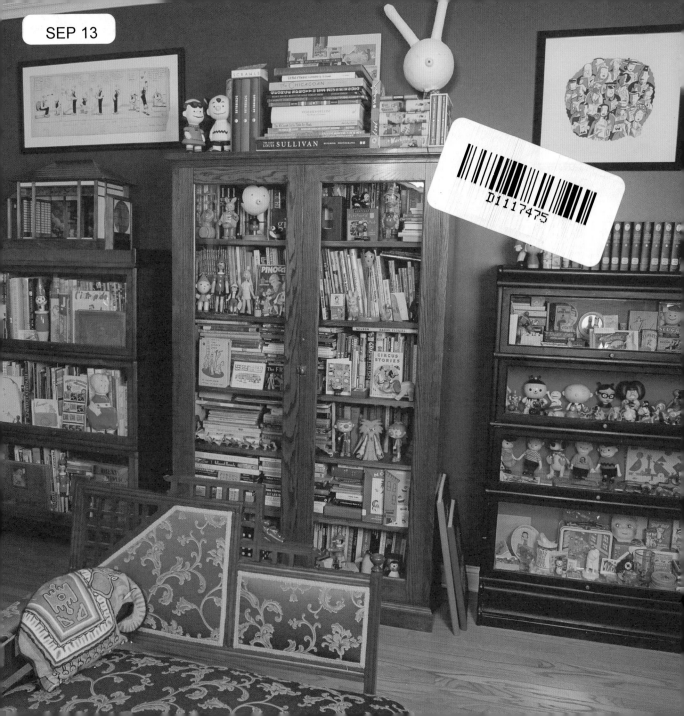

SEP 13

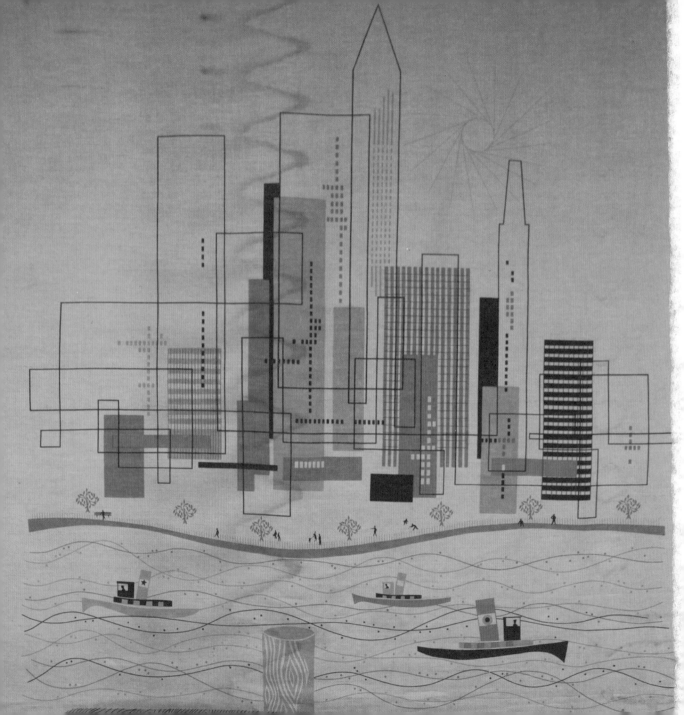

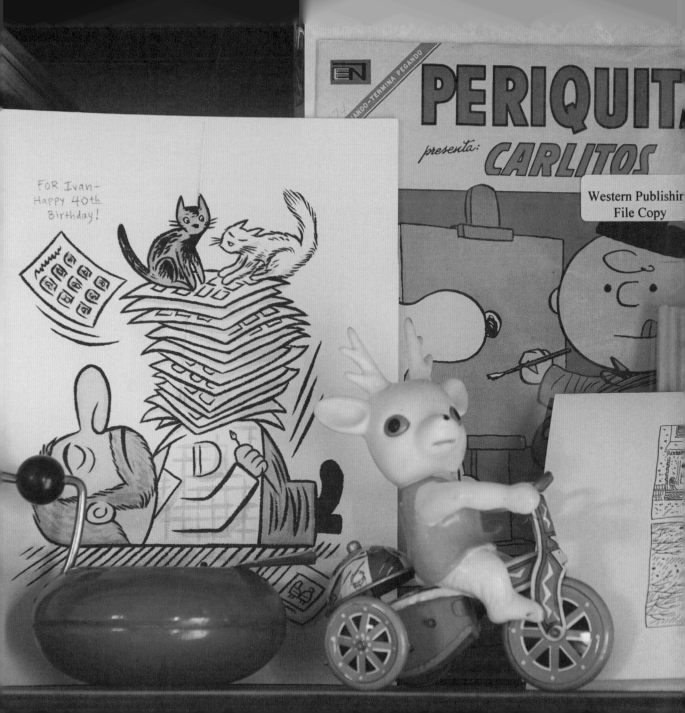

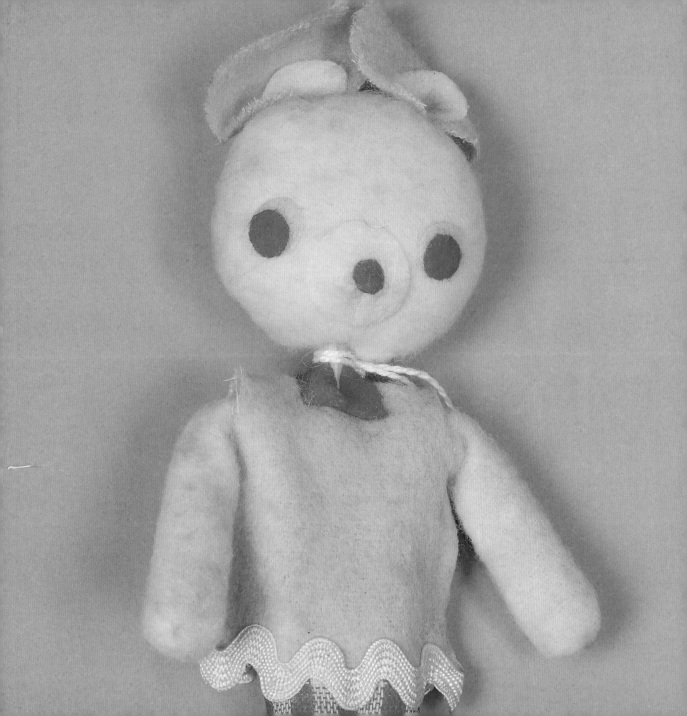

AESTHETICS

AESTHETICS

A MEMOIR · IVAN BRUNETTI

YALE UNIVERSITY PRESS
NEW HAVEN + LONDON

yalebooks.com

ISBN: 978-0-300-18440-2

Library of Congress Control Number: 2012950659

A catalogue record for this book is available from the British Library.

This paper meets the requirements of ANSI/NISO Z39.48-1992 (Permanence of Paper).

10 9 8 7 6 5 4 3 2 1

Printed and bound in China

THIS MODEST RETROSPECTIVE grew out of an even more modest catalog published for my "Aesthetics: A Memoir" exhibit at the Faculty Center of Columbia College Chicago from September 2 to December 18, 2009. I would like to thank everyone who made both the original exhibit and its accompanying booklet possible: Louise Love (who suggested the whole endeavor), Pegeen Quinn, Bob Blandford, Monica Wojtyna, Edward Thomas, and Abigail McLean. Thanks also for the generous support from the Columbia College Art and Design Department, especially Jay Wolke, Debra Parr, John Upchurch, Franklyn Busby, and Cat Bromels.

Book design by Abigail McLean.

Photography throughout the book is by Andy Burkholder, Ray Pride, Erin Rose, Angela Scalisi, and Jonathan Wilcox, as noted. The photos on the case covers are by Kurt Lauer. The photo series at the beginning and end of the book (of my surroundings, inspirations, and obsessions) are by Jonathan Wilcox, except for the living room, cloth rabbit, and circus glasses, which are by Angela Scalisi.

I can't forget the fellows in the Columbia woodshop who generously helped me construct my silly wood projects: Nate Carder, Chris Kerr, Geoff Prairie, and Jim Zimpel.

Many thanks to Jonathan Bieniek for his ace proofreading skills, Kevin Budnik for his invaluable production assistance, and Marieke McClendon for lending a designing hand. Thank you, Avis Moeller, for generously donating your childhood Pinocchio toy to my collection.

I would also like to extend a heartfelt *Merci* to Françoise Mouly for her infinite patience and kindness. In addition, I want to thank everyone whose friendship and conversations over the years have helped shape my artistic pursuits, especially Kevin Budnik, Thad Doria, Nick Drnaso, Anton Kresich, Matthew McClintock, Daniel Raeburn, Jeremy Smith, and most of all Chris Ware.

Last but certainly not least, thank you to Laura Mizicko for putting up with my moods, cavils, outbursts, and breakdowns.

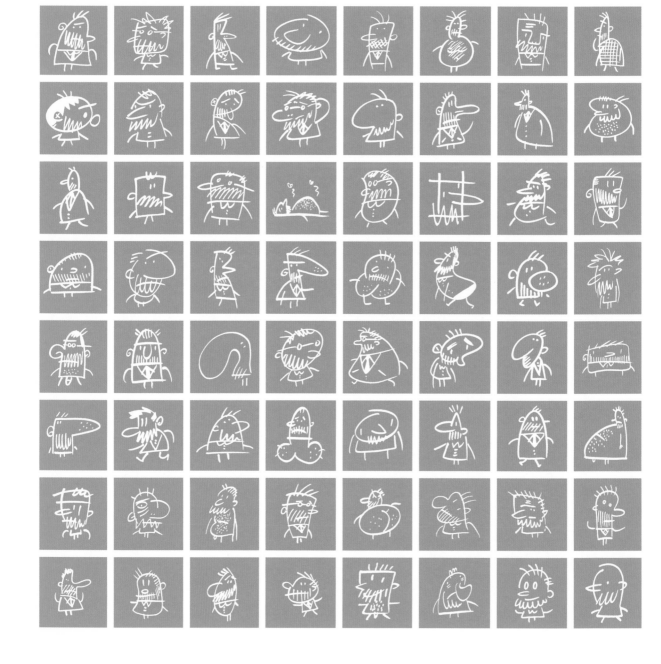

introduction

FACING PAGE:
64 Self-Caricatures Doodled on My Lunch Breaks, 2003.

FOLLOWING PAGE:
Self-Portrait, 2011.

I LEARNED NOT only how to read from comic books, but also how to see. I learned about line, shape, color, value, space, texture, color, balance, harmony, unity, contrast, variety, rhythm, repetition, emphasis, continuity, spatial systems, structures and grids, proportion and scale, and composition by studying and copying the drawings from the comic books of my Italian childhood. The word *disegno* literally meant drawing, but also design. Thus, the two were forever fused in my mind, each inseparable from the other: drawing is design, and design is, essentially, drawing.

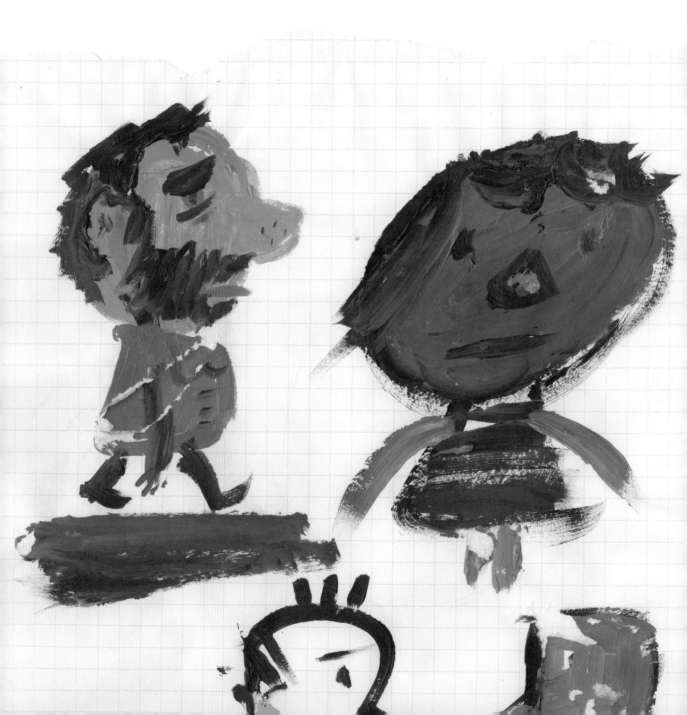

After my family moved to the United States, the *Last Supper* was an image I saw over and over in the many Italian-American homes we visited. Every reproduction was different in style and media, but somehow the same. It was as if an ideal, Platonic version existed somewhere, multiplying and slightly distorting itself with each iteration. I remember making my own botched paint-by-number version. This translative process, too, fascinated me.

My eyesight has always been terrible (and getting worse each year), and as a result my artwork is a distorted, flattened, cross-eyed interpretation of the world, only minimally connected to consensus optics. I have tried to convert this severe limitation into an idiosyncrasy. A pre-derangement of the senses.

I have almost no formal training, save for three basic art classes in college. The closest I came to "art school" was the few months I spent in 1994 drawing 60 *Nancy* comic strips in the style of Ernie Bushmiller in my abortive attempt to get a job as a traditional daily strip cartoonist. I learned almost as much as I did when I was a kid copying Mickey Mouse, day after day, learning to appreciate the beauty of the painstakingly simple.

The only thing I have ever been able to do with any competence, in fact, is make simple characters out of simple lines and simple shapes and put them into simple little boxes with simple little words. So that is what I do. Perhaps I am merely trying to vindicate my 8-year-old self. I am aware that there is no originality in my work, that pretty much all I am doing essentially is making my own version of *Peanuts* (crossed with Robert Crumb) and a vastly, hopelessly inferior one at that.

No matter. I am happy to be a subatomic particle whizzing around inside the seemingly infinite ocean of cartooning. I believe that cartooning, we shall always have with us. The calligraphic quality that I see in cave paintings is still there in Kandinsky and in Leonardo's beard in red chalk and in the way Charles Schulz drew Patty's hair in the early *Peanuts* strips. The line in all its incarnations is, to me, the mind asserting itself, absorbing and transforming experience. We cartoonists are trying to perfect a blend of drawing and writing, via observation, memory, and imagination.

I hope, in some small way, to contribute to this Sisyphean quest, even though, ultimately, everything will be ground to dust and forgotten and reborn into something else, over and over and over again, world without end.

Ivan Brunetti
Chicago, Illinois

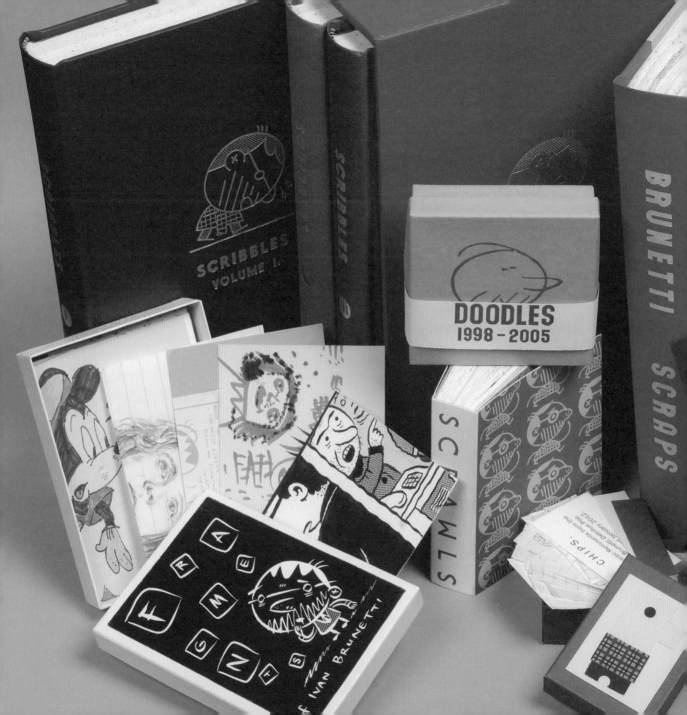

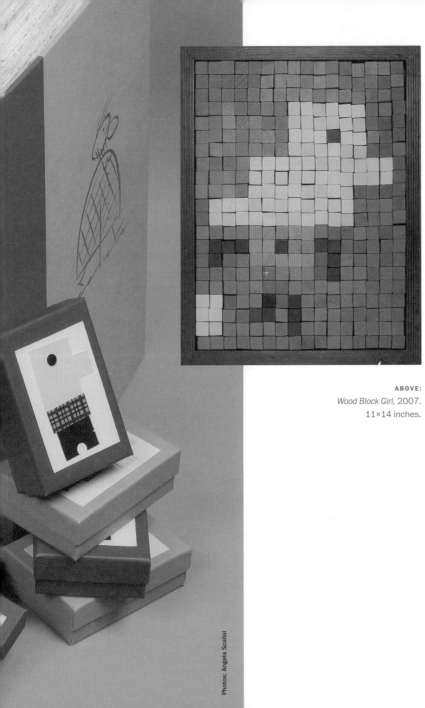


ABOVE:
Wood Block Girl, 2007.
11×14 inches.

Photos: Angela Scalisi

ALTHOUGH I AM assembling this book partially as a retrospective, there is, regretfully, very little *retro* to *spect*. Nevertheless, I believe one has to wring any speck of dignity possible out of one's life.

Since most of my time is spent doodling in cheap notebooks or on any handy, expedient sheet of paper, writing endless lists of drawings, comics, and other projects that I feel an obligation to make—but never actually seem to get around to making—sketching the same things over and over, compulsively and pointlessly revising ideas *ad infinitum*, I occasionally have to purge myself of this damning evidence, this testament to a creative life ill-spent.

However, when the self-loathing slightly diminishes, I feel a panicky urge to minimize the wreckage and salvage what I can, in order to preserve and commemorate even the slightest act of creation, to elevate the most minuscule of my accomplishments.

Some examples of the bound volumes (books and boxes) I have made out of my cut-up sketchbooks: *Scribbles, Scrawls, Scraps, Doodles, Fragments*, and *Chips*.

ABOVE:
Diptych (after Ernie Bushmiller), 2007.
Originally, I was crudely mapping out a makeshift mosaic made out of children's toy blocks (see previous page), but in the process I defaulted to images of Nancy and Sluggo. Clumsily drawn with a mouse, using the pencil and bucket tools in Photoshop.

NEXT TWO PAGES: *72 Doodles*, 1998–2005.
I have probably thrown away thousands of these scraps of paper. I tend to scribble and scrawl compulsively, absent-mindedly, with the vain hope of incorporating some of the resultant spontaneity into my rather uptight "finished" artwork.

THIRD PAGE FOLLOWING: *Gift for Laura's Birthday*, 2007.
I was at a creative impasse throughout the summer of 2007. During this inexplicable funk, I turned to "drawing" with a knife and color paper, and I made this small piece as a gift for my wife. This modest drawing is 3 inches square, so I thought it would be amusing to frame it ornately, with double matting. The woman at the frame shop chuckled appreciatively and threw in museum glass for free.
Photo: Angela Scalisi

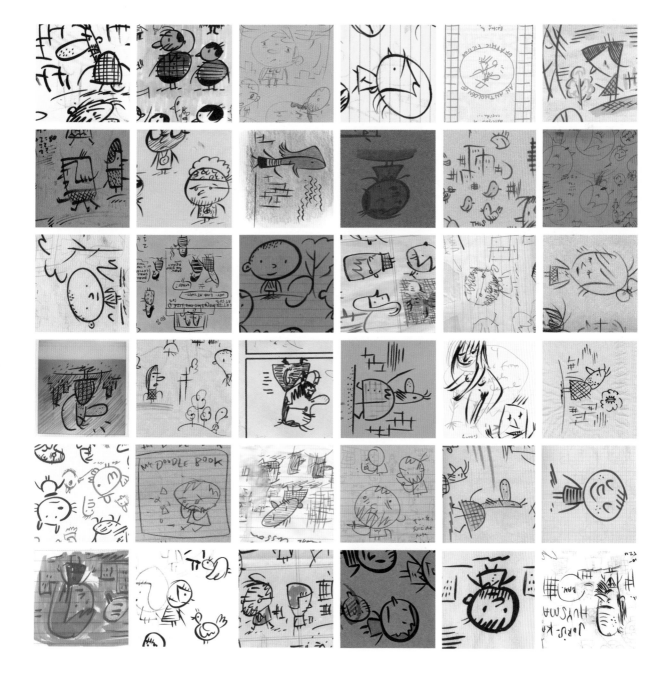

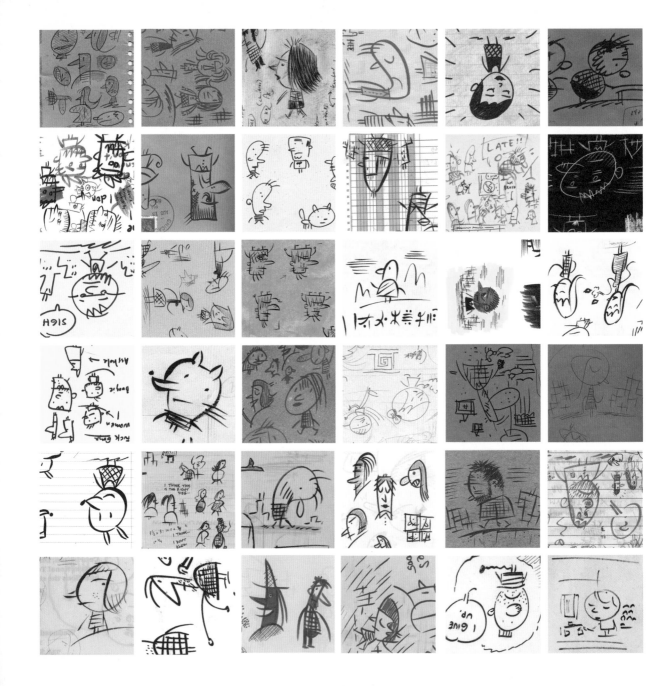

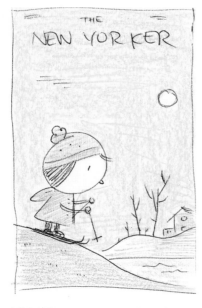

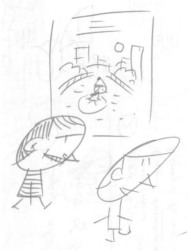

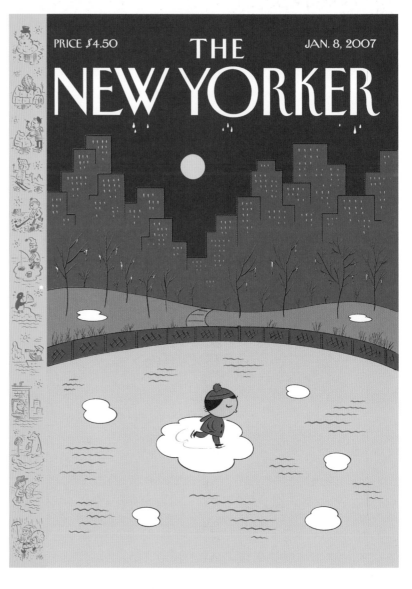

TOP LEFT:
The original sketch.

BOTTOM LEFT:
Another preliminary sketch.

ABOVE:
Submitted cover art for the *New Yorker* magazine, unpublished.

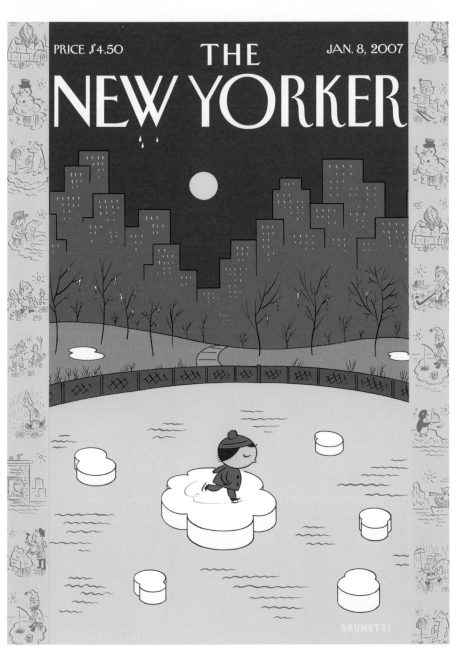

Cover of the *New Yorker*, January 8, 2007 ("On Thin Ice").

The original theme of my first sketch was "winter sports," with a sneaky nod toward global warming. The *New Yorker*'s art director, Françoise Mouly, suggested switching the scene to a skating rink and having more global warming scenarios in the vertical strap. She later suggested the rarely used "double strap" to act as a sort of curtain for the scene.

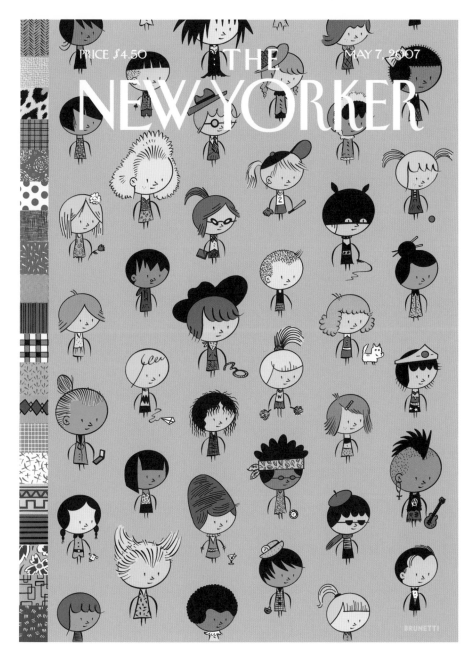

LEFT: Cover of the *New Yorker*, May 7, 2007 ("Style Sheet").

BELOW: First version of the black-and-white art.

This cover grew out of a small print I made with a Japanese "Print Gocco" device (see detail on facing page), as well as seeing a lot of "zwinkies" on the Internet (a digital version of the paper doll, with changeable hairstyle and outfits). I created a template sketch for the girl and then drew as many variations as I could think of. Françoise Mouly encouraged me to add more props and to vary the layout, as can be seen by comparing the initial and revised covers. Some trivia: I was asked to remove the cigarette from the French girl.

Thirst, an exhibit for The Aerial Gallery, which consisted of 50 serialized artworks printed onto 3×8 foot banners along Las Vegas Boulevard (on display from February 2008 to February 2009). The commission was an unusual one for me, in that I had zero experience creating "public art." I decided on a continuous, circular sequence that could be read in an endless cycle (the banners were actually laid out in a loop on the boulevard). The city's beloved and colorful mayor Oscar B. Goodman makes a cameo.

An anecdote: a small, isolated portion of each banner image was covered with a special film designed to glow in the dark, but Las Vegas is so bright at night that the banners actually glowed much more during the day.

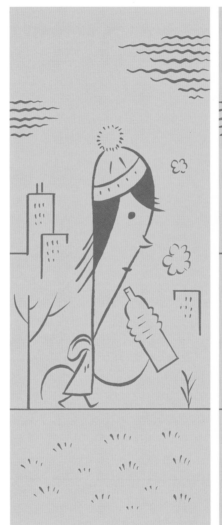
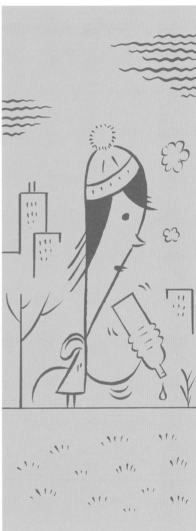

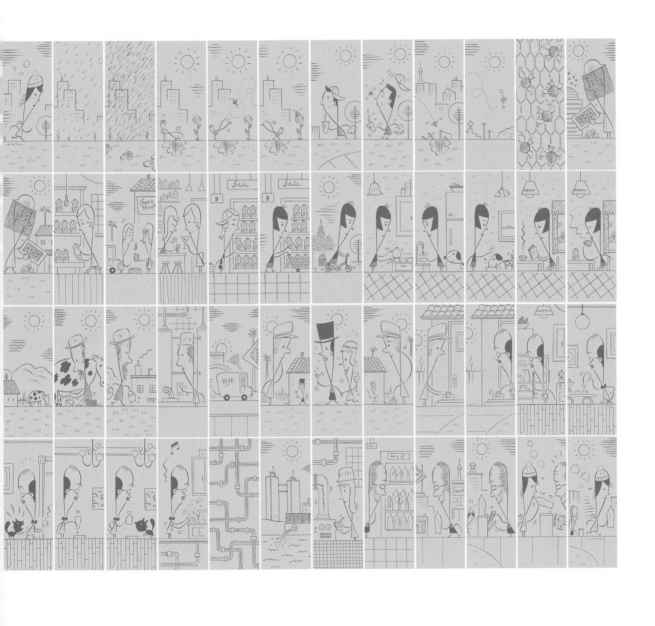

American Splenda, 2008.

This strip appeared in *Kramers Ergot* Number 7, an oversized (16×21 inches) hardcover anthology of comics. I drew the first half in 2007, set it aside for many months, and then drew the second half in 2008, although the strip technically takes place in one day, flashbacks notwithstanding.

I was working several jobs at the time (full-time as a web designer, part-time as a teacher at two different schools); somewhere in there I also edited two comics anthologies, while occasionally moonlighting as a freelance illustrator and cartoonist. As can be seen in the strip, I was neglecting my health and eventually ended up in the emergency room (and over time began neglecting my health again).

Negotiating corporeal reality has always been a struggle for me, and I tried to reflect this in the content and structure of the story, the reader having to hoist

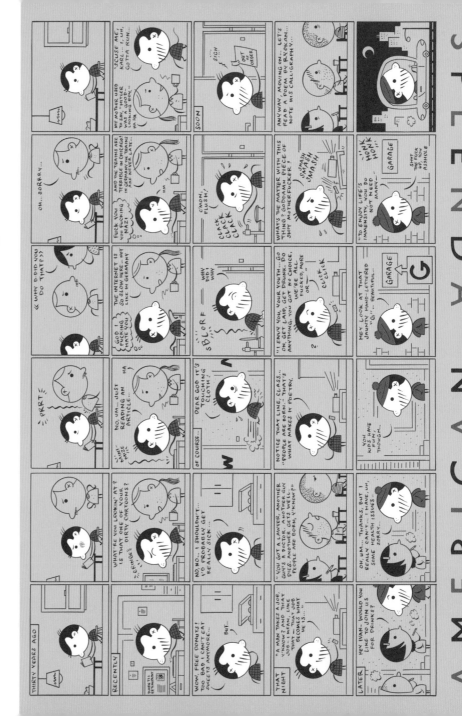

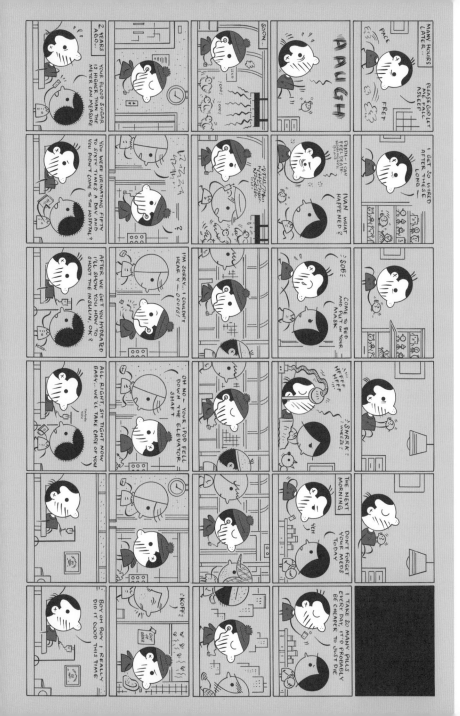

and rotate the unwieldy *Kramers Ergot*. The effect is admittedly much diminished here, but no one cared the first time around, either.

As a child, my line was carved, shaky, and deliberate. Then I quit drawing for many years (in therapy, I refer to this as "the dead time"). When I began drawing again, my line slowly evolved into something more calligraphic—sharper, angrier, and imbued with false bravado. Eventually I sputtered out, and what resurfaced was a lasered line—neutral, mechanical, and geometric.

This bloodless, armored approach has served me relatively well for most of the projects in this book; however, as of late this, too, has begun to outlive its usefulness, and once again the line is tangling, unlearning itself. As I write this in autumn 2012, I have no idea what will arise next, if anything.

One's drawing simply reflects the true nature of one's life at any given moment, despite delusion, despite subterfuge, despite skill. No mark is meaningless, and every line is an ideology.

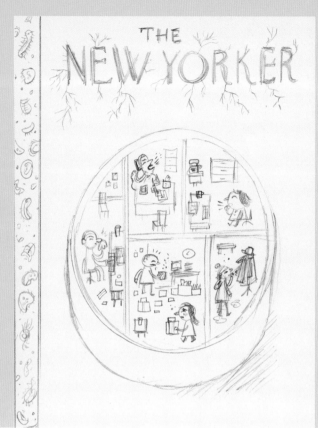

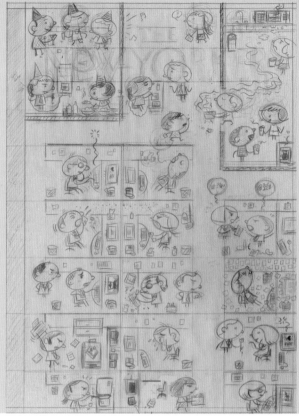

LEFT:
Initial sketch for the cover.

RIGHT:
Final pencil rough for cover
of the *New Yorker*, March 2, 2009
("Ecosystem").

I have a compromised immune system and am prone to many illnesses during the
winter months. I thought it would be funny to draw a typical office as a Petri dish,
with the germs flowing from cubicle to cubicle, but the initial sketch is a bit unclear.
Again, Françoise Mouly came to the rescue and suggested drawing a cutaway view
of a typical office, with the cubicles acting akin to comics panels, thus allowing for
a narrative approach within one drawing. Then, we streamlined my sketch into one
overall scene.

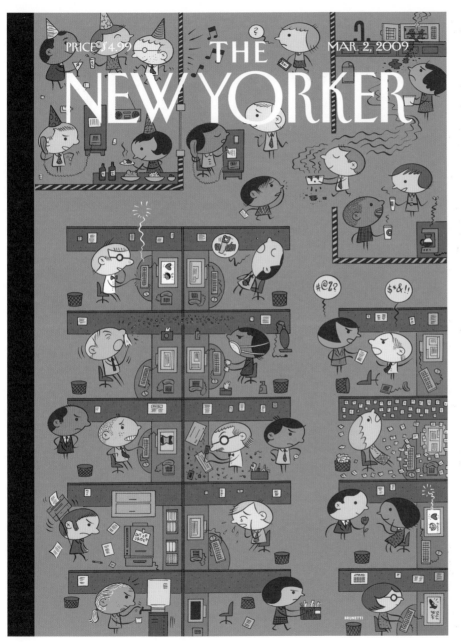

Cover of the *New Yorker*,
March 2, 2009 ("Ecosystem").

As can be seen here, the initial "germ travel" concept eventually became a small part of a larger composition, with other little stories thrown in. I couldn't come up with any workable perspective(s) for the scene, so I simply invented my own. Problem solved.

I also wanted to mention that I consider these covers a collaboration between Françoise and me. There is a lot of back-and-forth communication during the sketching stage, and sometimes even after inking and coloring. Pretty much all the good ideas in my *New Yorker* covers were Françoise's.

I love working with Françoise because she is the only art director I know who is sensitive to the architectural aspect of composing not only comics but also single images. It has been a great pleasure and honor to work with her, especially because *RAW*, the comics and graphics magazine she co-edited with her husband (Art Spiegelman), is one of the main reasons I became a cartoonist to begin with.

RIGHT:
Cover of the *New Yorker*,
September 7, 2009
("Required Texts").

ABOVE:

The first sketch I
submitted. The finished
drawing was an inversion
of the original gag. When
in doubt, flip the idea.

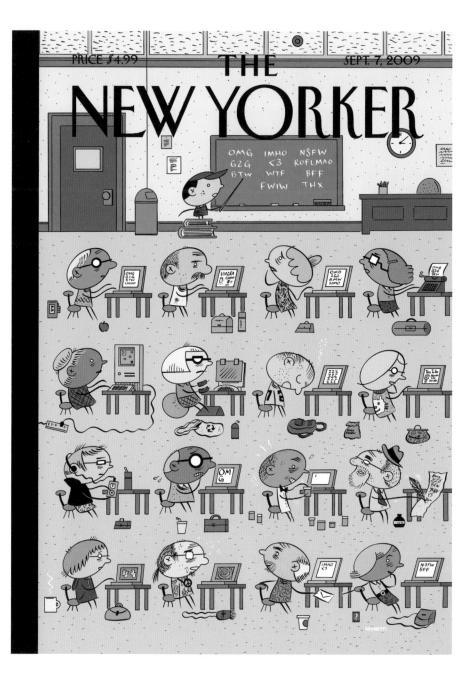

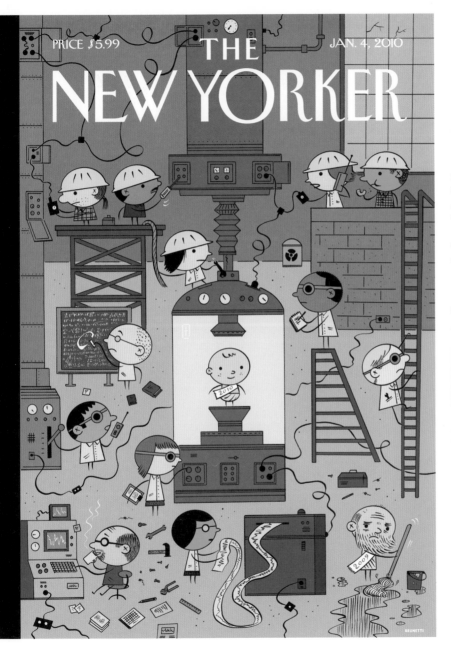

LEFT:

Cover of the *New Yorker*, January 4, 2010 ("Ring Out the Old, Ring In the New").

Another version of my own concocted quasi-perspective. My credo: if you know you can't do something right, then do it as wrong as possible.

ABOVE:

The initial concept, more complicated and not as funny. Comedy demands a certain mathematical elegance.

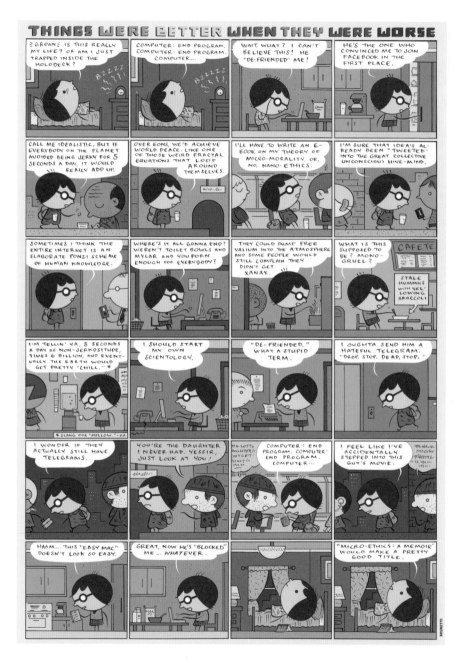

LEFT:

Comic strip that appeared under the heading "Sketchbook" in the December 21 & 28, 2009, issue of the *New Yorker* (the theme was "worldchangers"). The title was eventually deleted. I'm not entirely sure anyone noticed (or cared), but the visual structure was meant to evoke a videotape that stops in the middle and then rewinds itself, which is what a normal workday feels like to me. Yes, I stole my own "a memoir" joke.

There exists an unpublished "sequel" comic strip, featuring the same unnamed character. The strip is completed but currently in *New Yorker* limbo, perhaps for the best.

—

FACING PAGE:

Frontispiece illustration for *The Comics of Chris Ware: Drawing Is a Way of Thinking*, edited by David M. Ball and Martha B. Kuhlman (University Press of Mississippi, 2010).

RIGHT:

Cover of the *New Yorker*,
February 15 & 22, 2010
("Biodiversity").

For the 85th Anniversary
issue of the *New Yorker*,
Françoise Mouly asked
Chris Ware, Adrian
Tomine, Daniel Clowes,
and me to create a
collaborative cover,
somehow incorporating
the magazine's mascot,
Eustace Tilley, with the
catch that each cover also
had to function individually.
This challenge was quite
intimidating to me, as
these were my cartooning
heroes, and I felt like
the "Ringo" of the group
(or perhaps the "Pete
Best"; Ringo is actually
underrated). I never
showed anyone my first
sketch, the pornographic
doodle below.

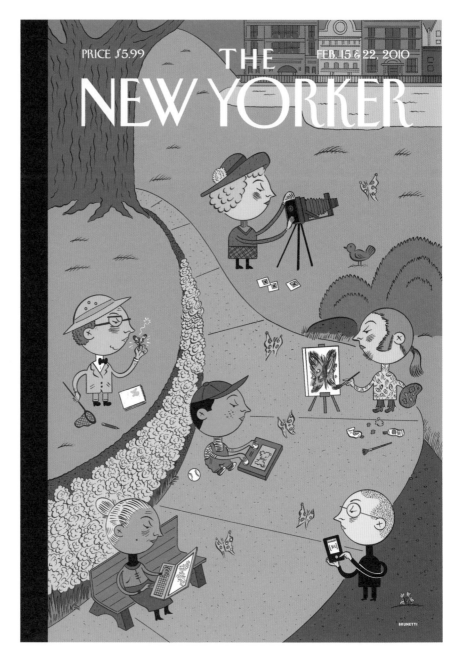

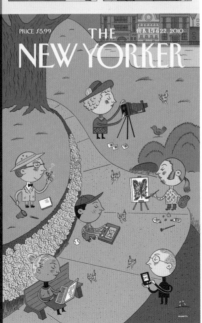

Despite my trepidation and complete lack of self-confidence, I did my best to keep up during the whirlwind brainstorming sessions (furiously conducted via email). We decided on the overall theme of "evolution" and wove an "origin of species" narrative for Eustace Tilley through the four covers. If you squint just right at the whole group of covers, you can also see a secret, embedded image.

LEFT:

All four covers for the February 15 & 22 issue of the *New Yorker*. Each issue featured two of the covers, at random. Thank you to the artists for generously allowing me to reprint their images.

TOP LEFT, Chris Ware ("Natural Selection"); **TOP RIGHT**, Adrian Tomine ("Adaptation"); **BOTTOM LEFT**, Daniel Clowes ("Survival of the Fittest"); and **BOTTOM RIGHT**, Ivan Brunetti ("Biodiversity").

RIGHT:
Cover of the *New Yorker*,
May 31, 2010 ("Union Square").

BELOW:
Two rough sketches,
showing the composition
slowly coming into focus.
As Françoise Mouly has
rightly noted, nothing
just *flows* from the tip of
my pen.

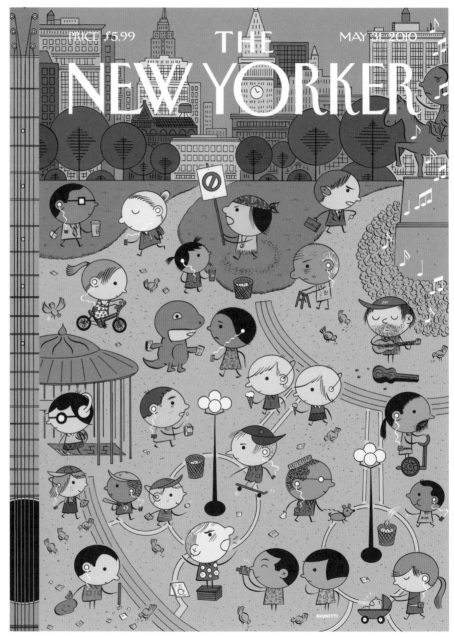

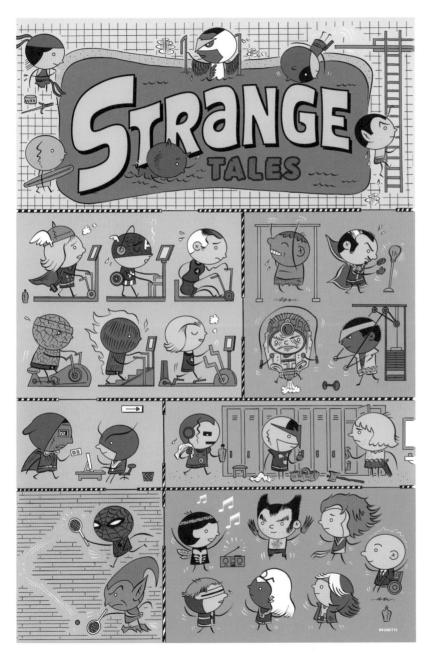

LEFT:

Cover of *Strange Tales*, Volume 2, Number 3, 2010. TM and © Marvel and Subs.

My Spider-Man–obsessed 10-year-old self would have been ecstatic: I got to draw a Marvel Comics cover! My jaded 43-year-old self was gratified that I got to draw the characters in my own style. Some advice to the discouraged: hold on to your dreams; if you can persevere, eventually reality will bend to your will.

BELOW:

The initial sketch, hastily scribbled after coming home from the YMCA.

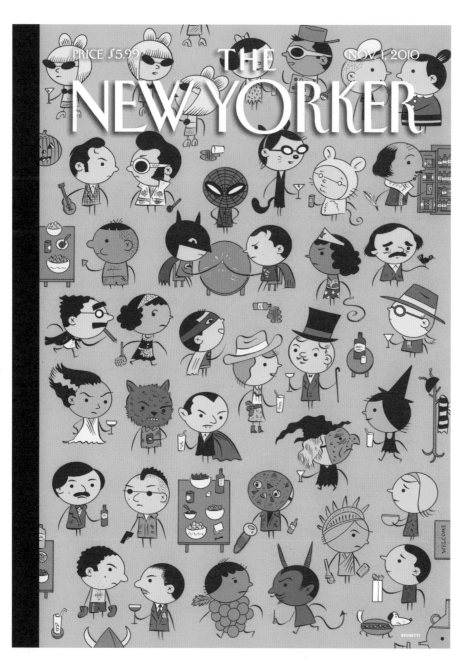

PRICE $5.99

THE NEW YORKER

NOV. 1, 2010

LEFT:

Cover of the *New Yorker*,
November 1, 2010
("Dressed Down").

BELOW:

A Halloween card I
designed for my comedian
pal Patton Oswalt, around
the same time I was
drawing the cover.

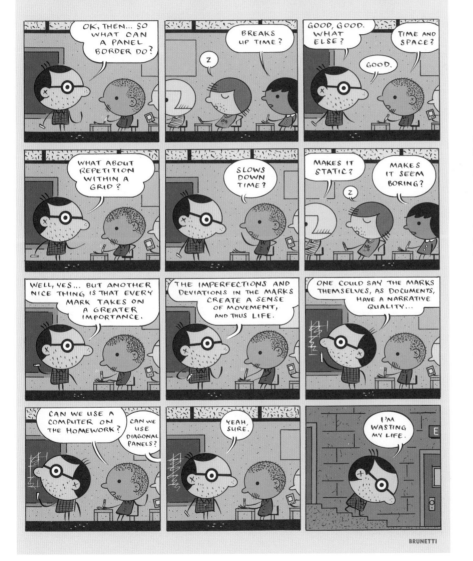

LEFT:
Mr. Peach, 2011.

Comic strip that appeared
in the March 7, 2011,
issue of the *New Yorker*.
As can be seen in the
submitted sketch below,
the strip was originally
much longer. Ironically,
I had to touch up the
strip rather extensively in
Photoshop.

BELOW:
The original sketch.

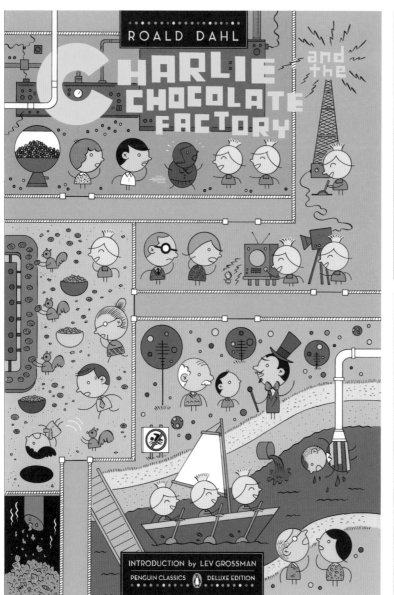

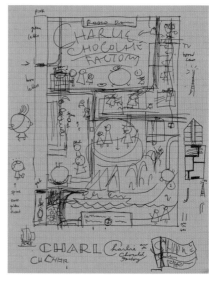

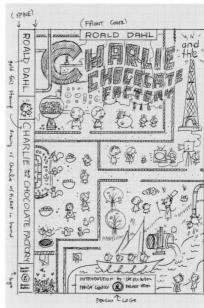

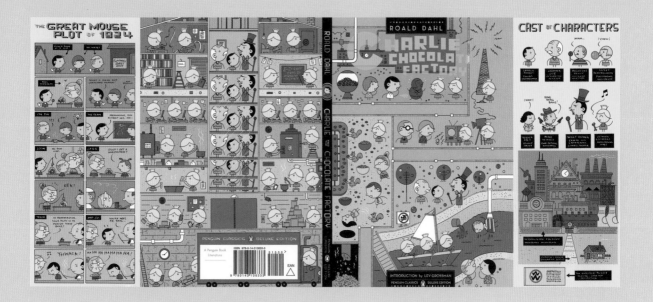

I REMEMBER MOPING and brooding one day, lamenting the fact that I was never asked to draw one of the Penguin Books Deluxe Edition covers, as many of my fellow cartoonists have been invited to do, and then admitting to myself that, objectively speaking, I was not worthy. A few days later, as if by the miracle of thought transference, I was asked to draw the cover of *Charlie and the Chocolate Factory*. I was elated, then terrified, and proceeded to procrastinate until the very last possible minute.

—

FACING PAGE (LEFT):
Front cover of Roald Dahl's *Charlie and the Chocolate Factory*, 2011.

FACING PAGE (RIGHT):
The sketches that got the whole process started.

ABOVE:

The whole wraparound kit 'n caboodle, fully assembled (front and back covers, spine, and French flaps). Some of the colors were slightly modified for the final, printed version.

Design for a silkscreened promotional poster advertising the June 2011 installment of The *Show 'n Tell Show*, a live extravaganza featuring interviews with designers, illustrators, and other artists, co-hosted by Zach Dodson and Mike Renaud (along with the enigmatic "Spokes Mom").

BELOW:
Quick preparatory doodle for the poster.

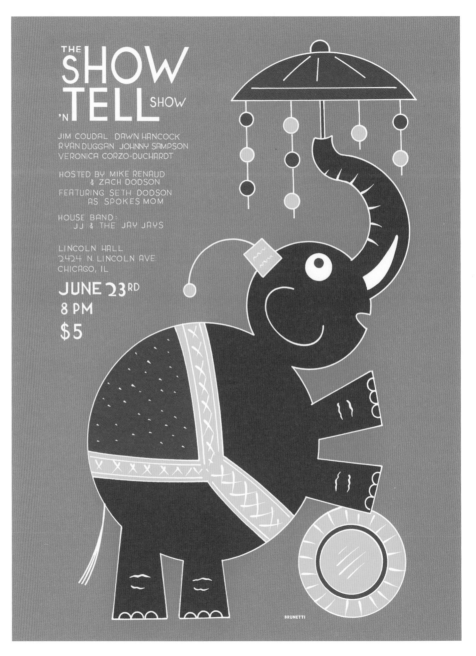

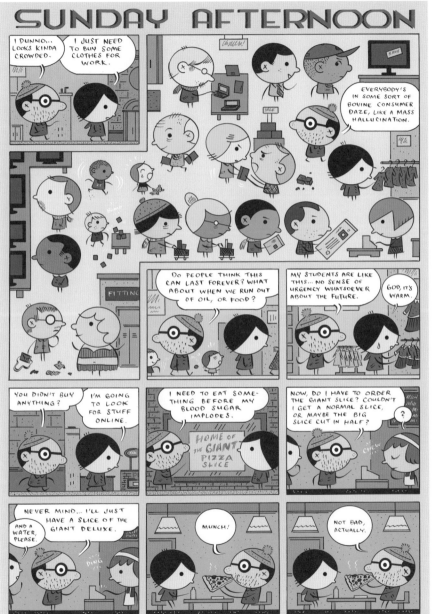

LEFT:
Sunday Afternoon, 2011.

Comic strip that appeared in the April 4, 2011, issue of the *New Yorker*. The submitted sketch included a scene of the "Ivan" character going into a men's room, which was deleted for the sake of space and propriety.

ABOVE:

A doodle from around the same time I drew the strip.

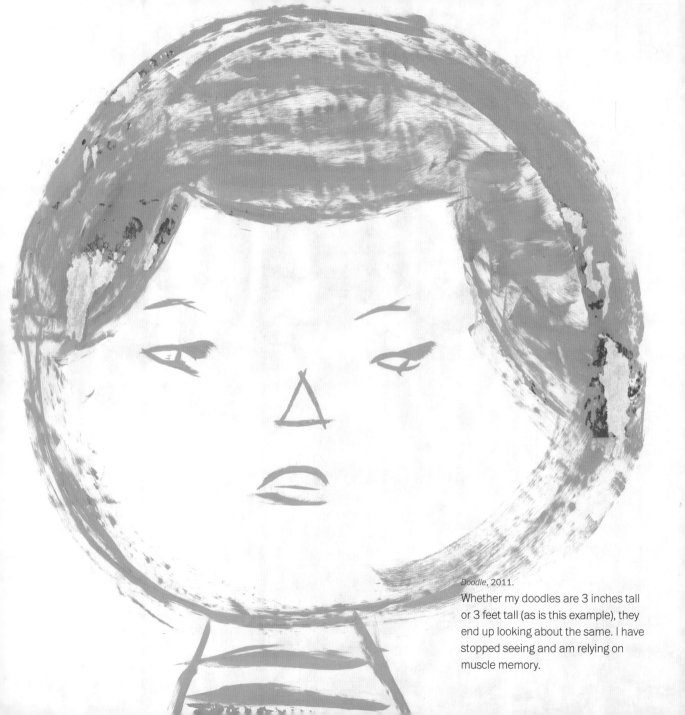

Doodle, 2011.
Whether my doodles are 3 inches tall or 3 feet tall (as is this example), they end up looking about the same. I have stopped seeing and am relying on muscle memory.

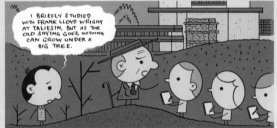

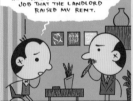
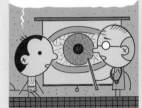
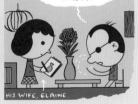

My eyesight has deteriorated to such a degree that when things turn out halfway decent, it is usually in spite of myself, a fortuitous stumble. I suppose this is probably the reason that, as a teacher, I encourage the embracing of mistakes and accidents. If I were a more sure-footed artist, then I would doubtless have a very different aesthetic sensibility and critical apparatus. Philosophy follows temperament, and temperament follows the cruel humor of biology.

LEFT:
Alvin Lustig, 2011.

Originally slated to appear in the *New Yorker*, bumped a few times, and later "killed" by my request.

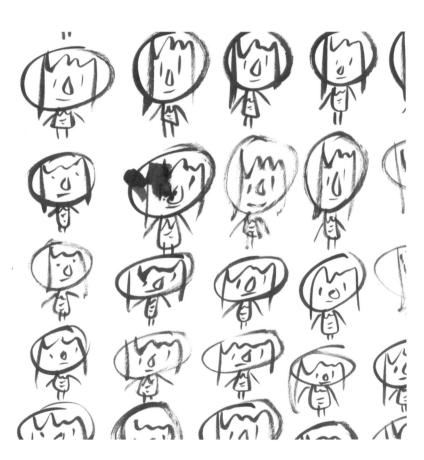

ABOVE:
Penance, 2011.

Drawn with a brush and India ink on a 3×30 foot scroll, featuring the same character drawn in the same number and order of strokes, over and over again (approximately 1,768 times).

When I was a kid, I enjoyed losing myself in these trance-like punishments, half-aware that something other than myself would "take over" the monotonous task. The putative sentence I was repeating would then animate itself, shifting and winding, slithering wavelike across the page despite my efforts to keep its form steady and unwavering.

RIGHT:
A detail at actual size.

—

FACING PAGE:
A small portion of the scroll.

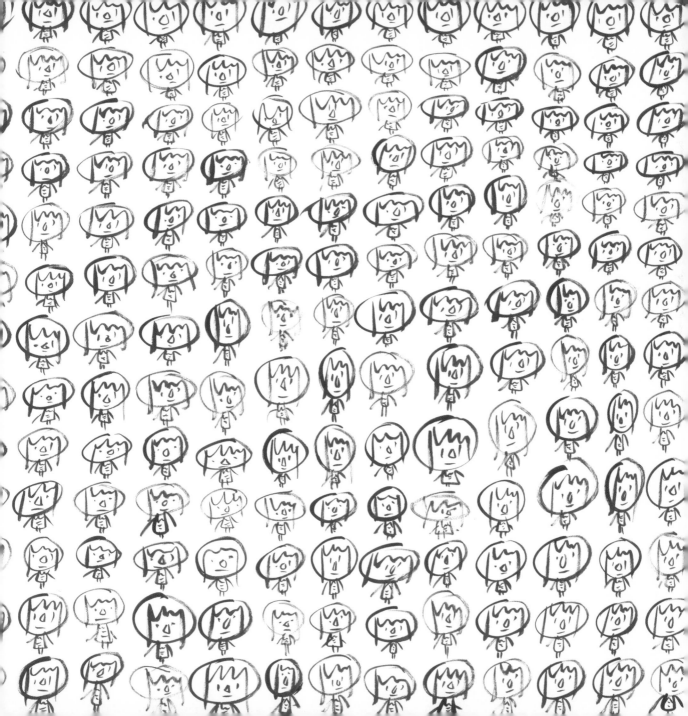

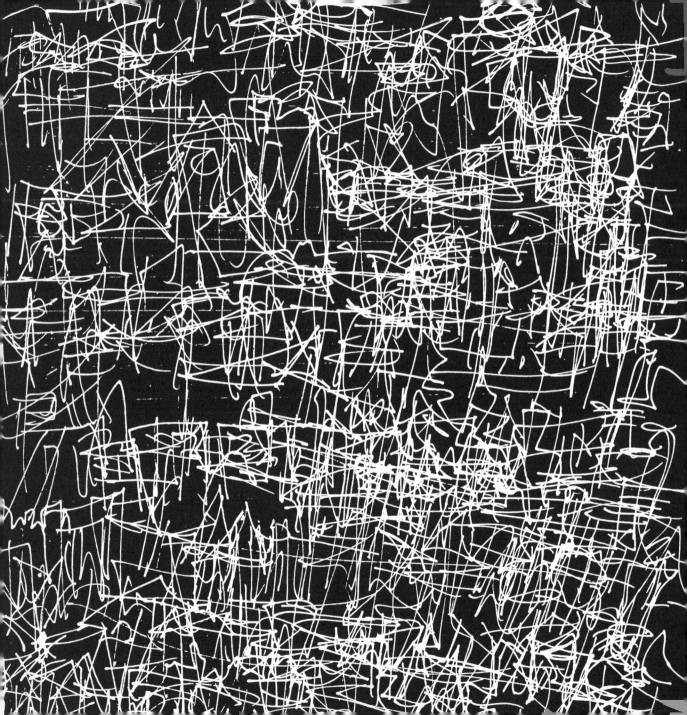

Mr. Peach, Part 2

RIGHT:
Mr. Peach, Part 2, 2012.

The first half of this story appeared in the March 7, 2011, issue of the *New Yorker*. The conclusion appeared in the third issue of *Linework*, a comics anthology edited by my students (print run: 100 copies).

FACING PAGE:
Cityscape, 1997/2011.

Drawn on a moving elevated train during a period when I was losing, but desperately trying to clutch onto, my sanity. I call this method "comprovisation," which I would define as that unbounded, nebulous space between the unpredictability of improvisation and the deliberate structuring of a composition. Is there really a point where one can consciously differentiate between the two?

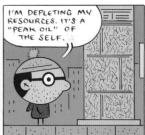

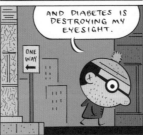
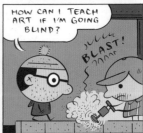
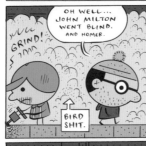
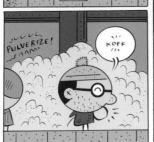
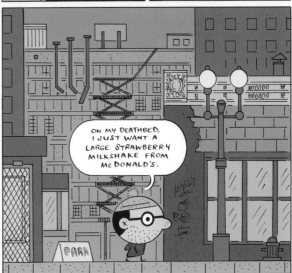

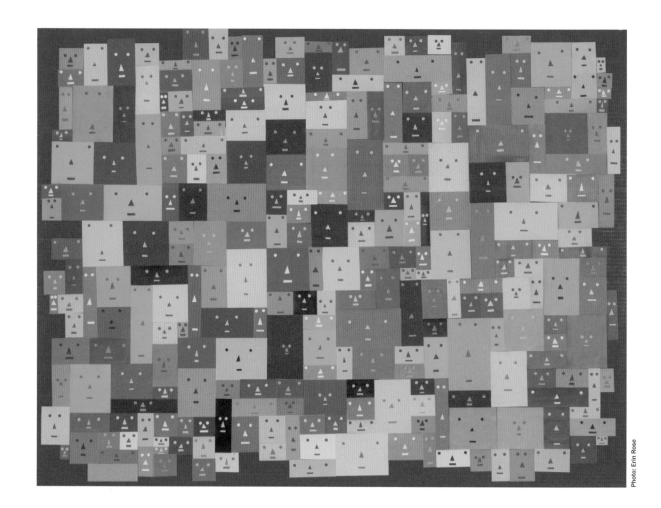

Faces, 2012.

This piece is 3×4 feet, made out of paint sample chips glued onto cardboard.

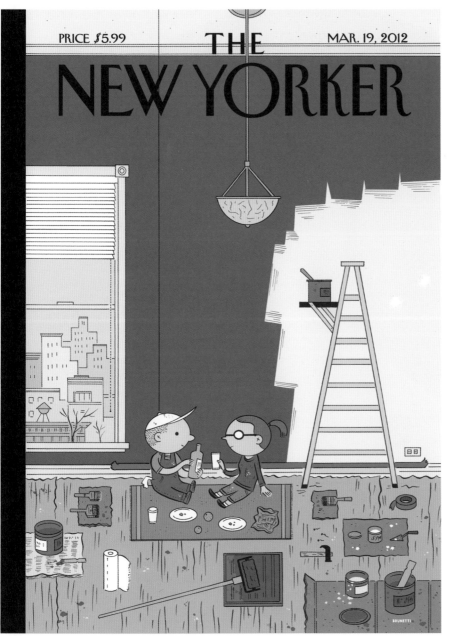

LEFT:
Cover of the *New Yorker*,
March 19, 2012 ("Warmth").

The root of this image: many years ago, weaving between depression and mania, I decided to paint all the rooms in my apartment with the same palette of eight colors that I use all the time in my comics. When I moved out, the landlord charged me to paint everything back to white.

ABOVE:
Little Orphan Annie, 2011.
Paint sample chips, 10×13 inches.

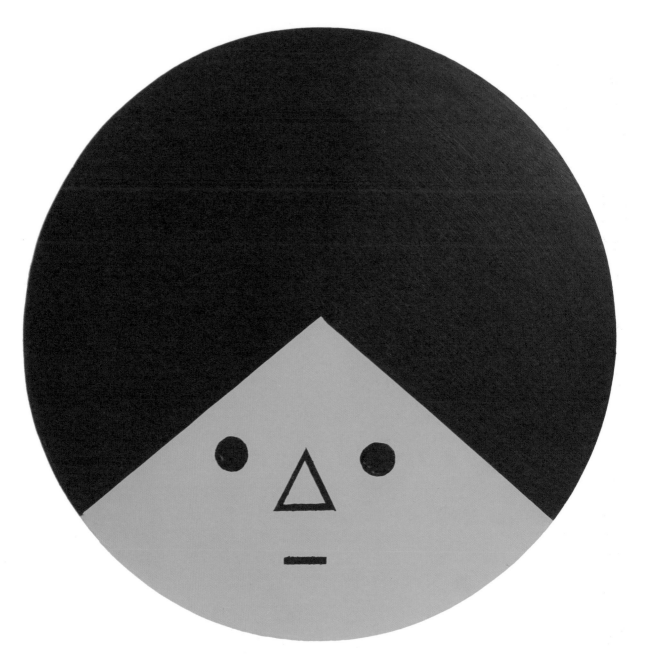

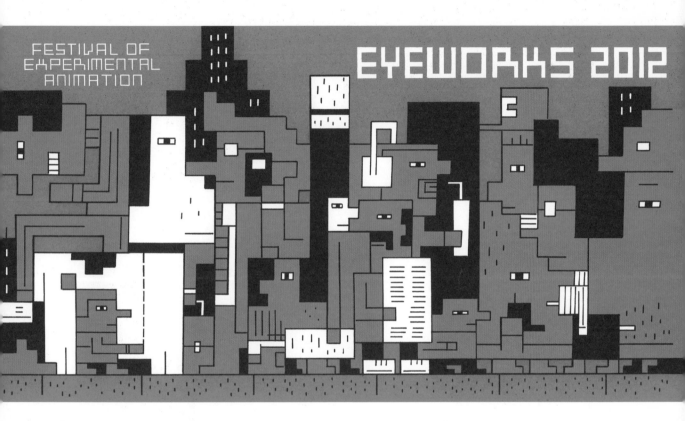

FESTIVAL OF EXPERIMENTAL ANIMATION

EYEWORKS 2012

ABOVE:

I was honored to be asked to draw the program cover for the 2012 *Eyeworks Festival of Experimental Animation*, run by Alexander Stewart and Lilli Carré. This image originated as a sketch for a possible mural, a fanciful notion I entertained while sitting in a stultifyingly barren room, attempting to distract myself from the goings-on at an interminable faculty meeting, lest my soul begin to hemorrhage.

FACING PAGE:

Head, 2012.

I found a wooden disk in the trash and painted over it.

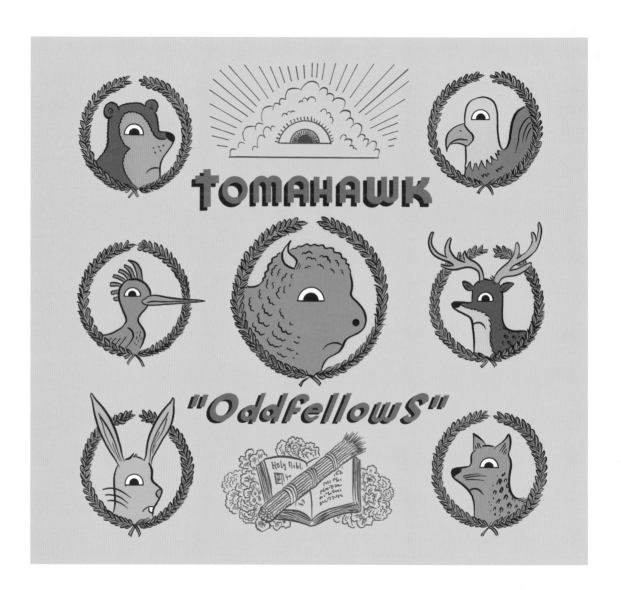

CD cover for *Oddfellows* by Tomahawk, 2012.

It was an honor working with musicians Mike Patton and
Duane Denison, geniuses and very nice fellows both.

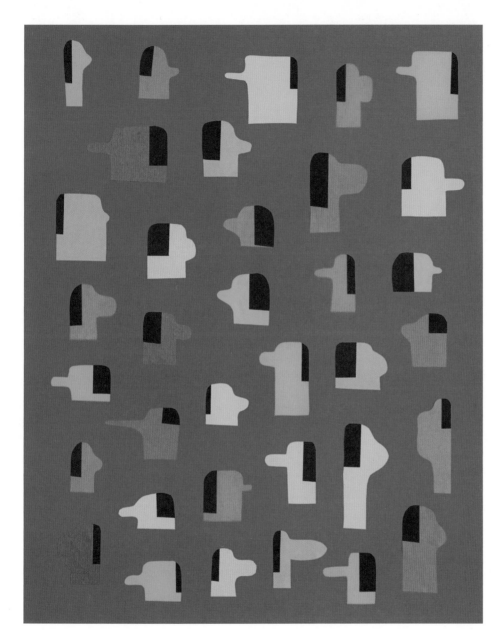

Snoopy Heads, 2012.
Construction paper on
poster board.

A torn-paper doodle.

ABOVE:
Some of my favorite artworks, these examples of urban fauna can be found in the northwestern portion of Chicagoland. Snapshots taken by my wife.

FACING PAGE:
Breakfast in America, 2012.
Autobiographical strip drawn for a *Guardian* special feature ("Cartoonists on the World We Live In"), in the July 20, 2012, issue.

BREAKFAST in AMERICA

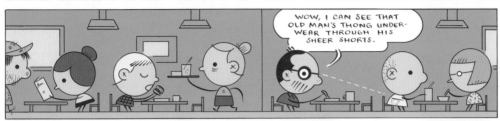

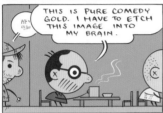

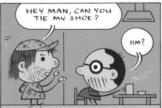

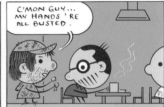

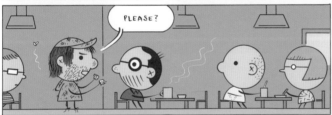

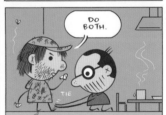

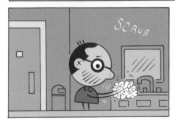

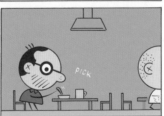

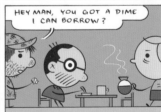

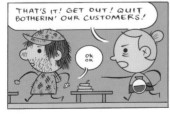

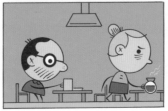

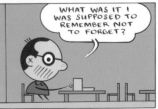

BRUNETTI

Misery Loves Comedy, c. 1988.

I include this sample from my college strip *Misery Loves Comedy* for two reasons: (a) self-mortification and (b) as incontrovertible evidence that anyone can learn to draw better, or at least find ways to refine their approach, through constant and vigilant practice.

Drawing is the one thing that slows down existence, that burns the world into your brain. And that mental map is absolutely necessary to draw comics. I tell my students: never stop drawing. It is hard to start again once you stop. Keep moving forward. Drawing is a bicycle, not a car.

Life will conspire against you, as complications inevitably pile atop responsibilities. Time is remorseless. Because our culture has a surfeit of artists, it is difficult to succeed; one often has to work against a multitude of obstacles and unfavorable circumstances. Perseverance is much more important than confidence or talent.

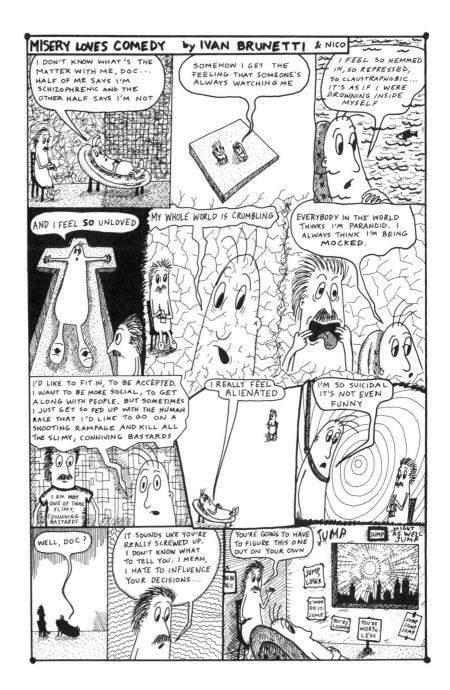

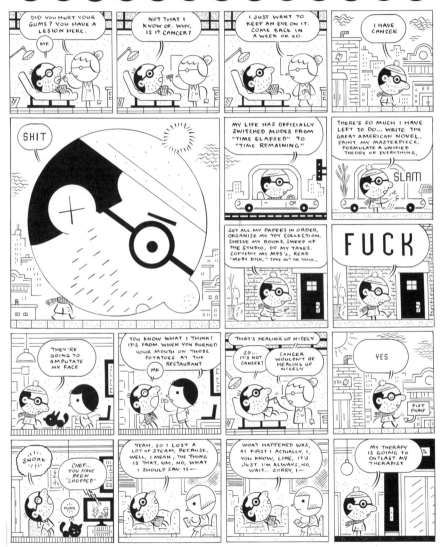

Autobiography, 2012.

My process, after some rough sketching, is to create a skeletal "underdrawing" with color pencil on a cheap sheet of newsprint, which I then tape to a light table. Over that, I place a sheet of Bristol board, Strathmore 500 Series (Plate surface), and refine the drawing with India ink, using a combination of technical pen (Koh-I-Noor Rapidograph No. 2) and dip pen (Hunt 102 crowquill nib).

Typically, I loathe my strips nearly as much as I loathe myself. If I'm not under a tight deadline, I will completely rethink, redraw, and reassemble a story multiple times, and then abandon all those ideas and come back to something close to the first rough pencil version.

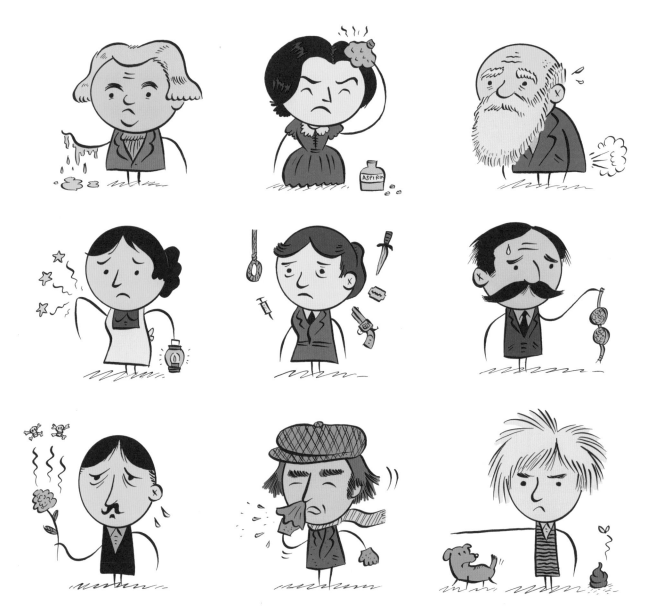

Photo: Ray Pride

Drawings for an article ("The Hypochondriacs") from *The Believer* magazine, February 2010, featuring James Boswell, Charlotte Brontë, Charles Darwin, Florence Nightingale, Alice James, Daniel Paul Schreber, Marcel Proust, Glenn Gould, and Andy Warhol. Some of the phobias depicted include melting flesh and dog feces.

I drew this logo for the oddly named bluegrass outfit Sexfist over a decade ago, but it must have legs, because to this day I still see it on flyers randomly scattered around Chicago.

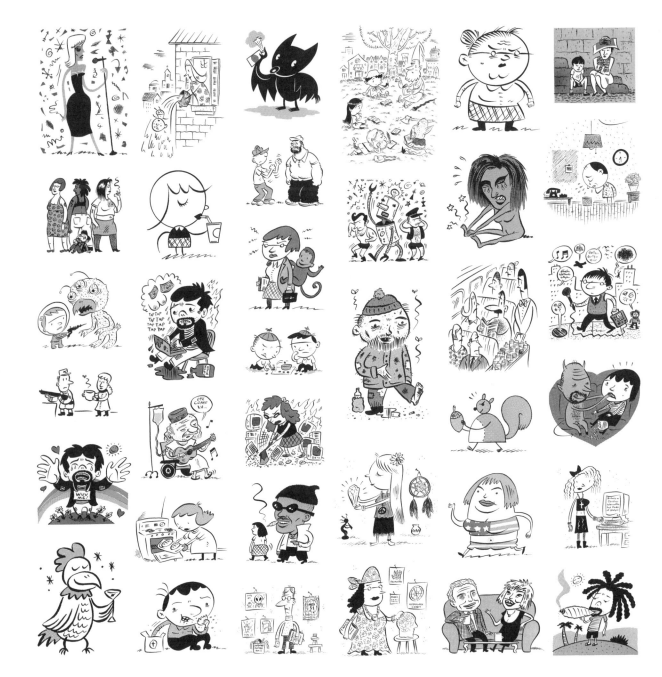

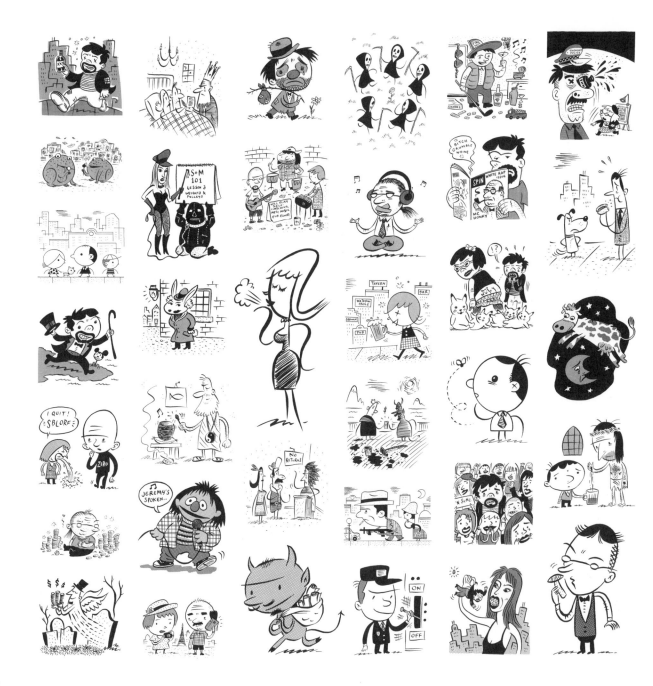

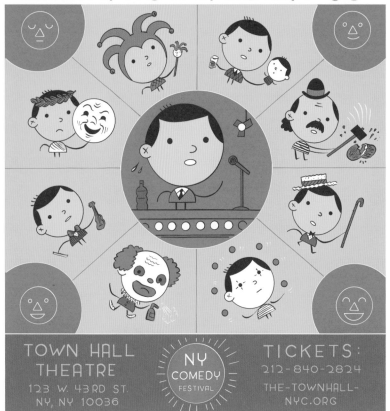

Poster for a Patton Oswalt show, 2012.
In 2009, I drew the covers for the CD and DVD of Patton's *My Weakness Is Strong*, and he was kind enough to write the Introduction for my book *Ho!* His speculation on the roots of religion ("Sky Cake") is one of my favorite comedy bits, worthy of Nietzsche.

PREVIOUS TWO PAGES:

A minute fraction of my "spot" illustrations, small drawings I provided for various publications over the years. Some projects I remember fondly, while others I have no memory of whatsoever—a melange of forgeries executed by a former self.

FACING PAGE:

Gag panel drawn for *The Cartoon Crier*, a sadness-themed newsprint comic strip anthology, published in 2012 as a collaboration between the National Cartoonists Society and the Center for Cartoon Studies.

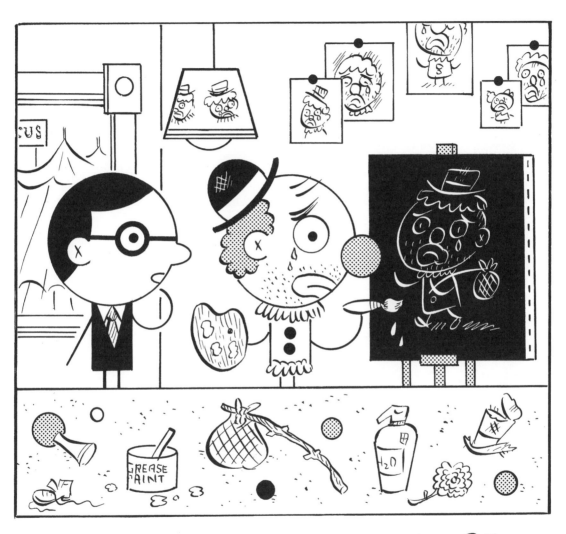

"Where do you get your ideas?"

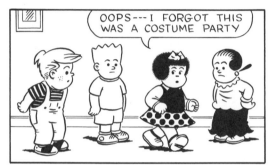

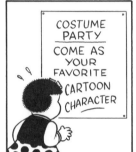

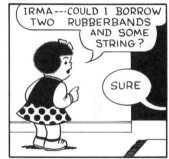

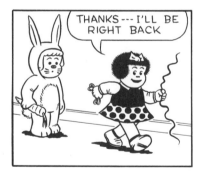

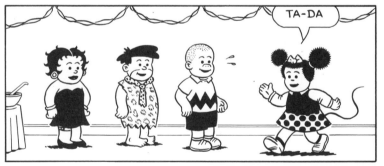

One of the Sunday strips from my unsuccessful tryout to become the new *Nancy* artist (1994). Most of what I know about the mechanics of cartooning comes from the rigor of copying Ernie Bushmiller's classic comic strip. It was good to submerge myself completely; swimming back up to the surface was rejuvenating.

FACING PAGE:
Landscape, 2012.

Louise Brooks, 2002.

This is the black-and-white original artwork for the strip, which was published in color about a year later on the late, lamented Highwater Books website.

Back then, I was composing all my pages in a sort of "Sunday comics" style, and I thought the strips looked somewhat naked in black and white; thus, I convinced myself that I could gussy them up—or at least hide the spatial and anatomical deficiencies—by adding color. Because I have always been a terrible colorist, I opted for a variety of limited color palettes (more akin to the silkscreen process than offset printing). I figured, learn how to color as you go.

Now, the color seems to me an unnecessary adornment, an obfuscation, an act of cowardice. I much prefer the bare, unfettered linework.

LOUISE BROOKS

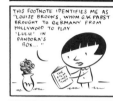
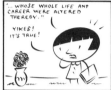
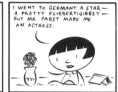
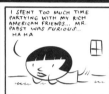
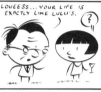
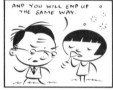
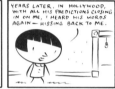
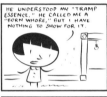
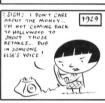
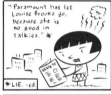
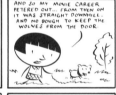
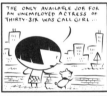
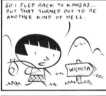
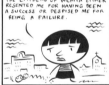
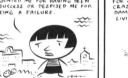

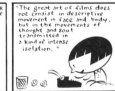
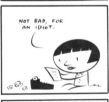
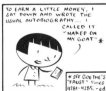
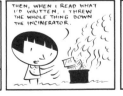
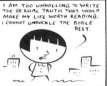
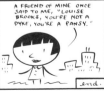

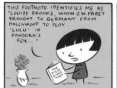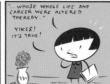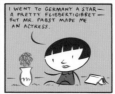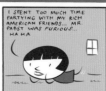
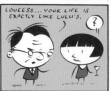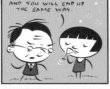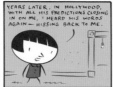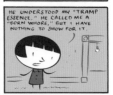
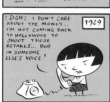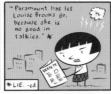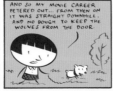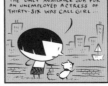
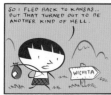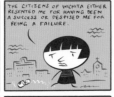
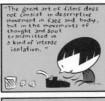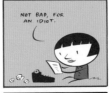
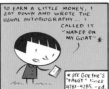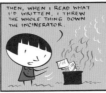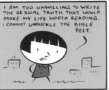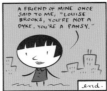

Louise Brooks (as collected in *Schizo* Number 4, 2006).

The truth is, I didn't appreciate anything about my drawing (or, more generally, life). Having been constantly reminded that I was stupid, ugly, and useless all through my years growing up, I made it a self-fulfilling prophecy. With time and distance, I came to understand that the redeeming qualities of my comics (and perhaps myself) were unintentional, that the aspects beyond my perception were, in fact, the interesting parts.

But how to achieve this interest, this redemption, with clear purpose and intention? Awareness is a Faustian confidence trick: a forgotten thing, a discarded thing, an overlooked thing may enter our consciousness, unable to exit, but by that very process it becomes not quite the same thing.

Bodhisattva Never Disparaging, 2005.

A comic strip drawn originally for the *Chicago Reader* (2005) and later published in the first volume of the anthology *Hotwire* (2006). Although the strip was published in full color, again I have come to prefer the black-and-white version.

After completing this page, years passed without my publishing any new comic strips. In 2008, I began teaching full-time, and that was all she wrote. Playacting the extrovert is a draining affair; regardless, I embraced my new profession and was engulfed by it, as I am not much of a multi-tasker. I began to think of my classes as a sort of performance art and my homework assignments as Sol LeWitt–style templates; hopefully, a few students found all this edifying.

Still, I wish I had forced myself to produce more artwork in the past few years. There isn't much point to framing one of my exquisitely honed syllabi.

FACING PAGE:
Accidental Abstraction, 2009.

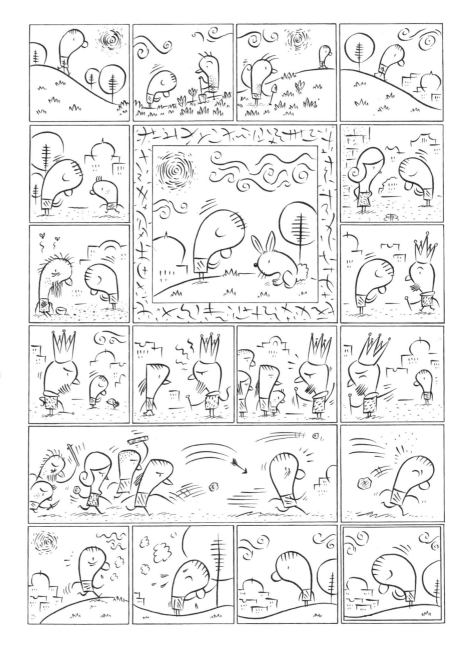

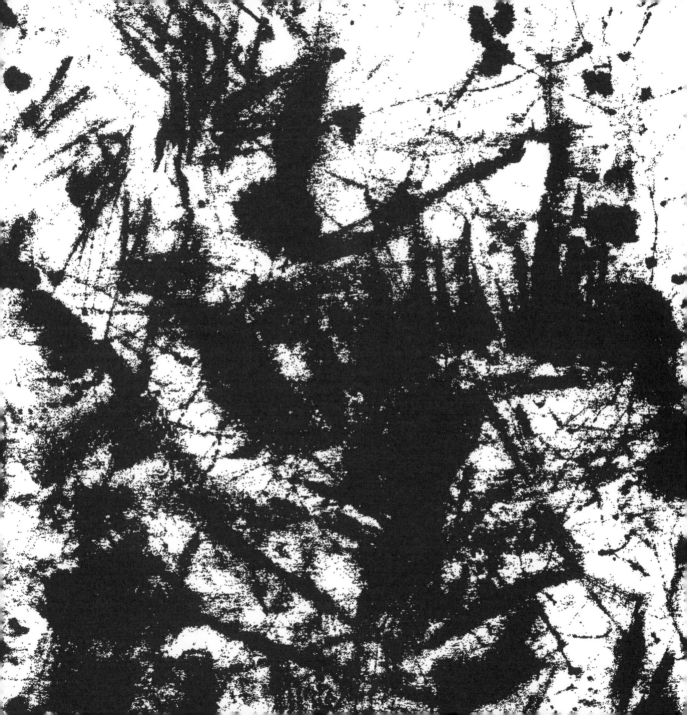

the comics journal

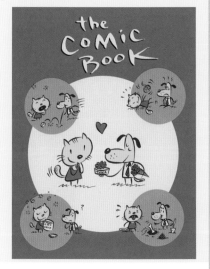

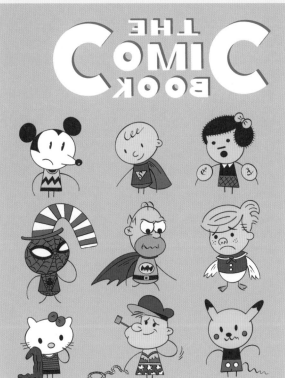

ABOVE:
Two covers for *The Comic Book*, a section of Nickelodeon's monthly magazine, from the February 2003 (Valentine's Day theme) and April 2007 (April Fool's Day theme) issues.

I had to send a color-indication sketch for approval ASAP on a day that I was at work, so I quickly re-drew the cover from memory (with only the computer mouse) on my lunch break. I prefer this drawing to the actual cover, in some ways.

FACING PAGE:
Section cover for *The Comics Journal Special Edition, Summer 2002.* Inspired by—but falling far short of—Saul Steinberg, I tried to use line and shape as synaesthetic approximations of musical sounds and textures.

FOLLOWING PAGE:
Black-and-white linework for comic-strip sequence to be printed as a miniature accordion booklet in two colors, as part of the *2w* series (this is set *V*) by Swiss publisher B.ü.L.B. Comix.

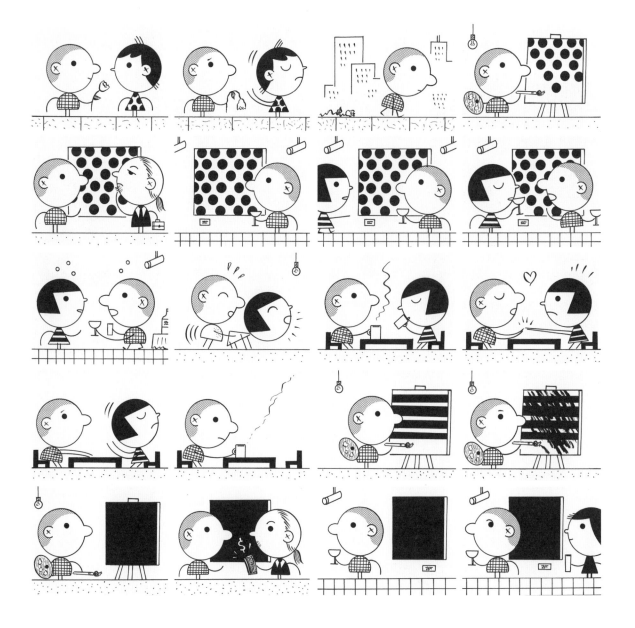

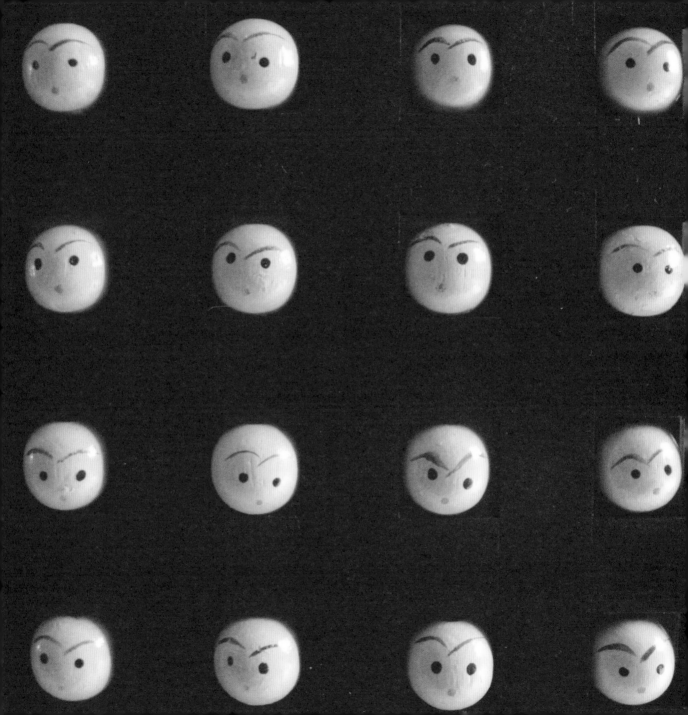

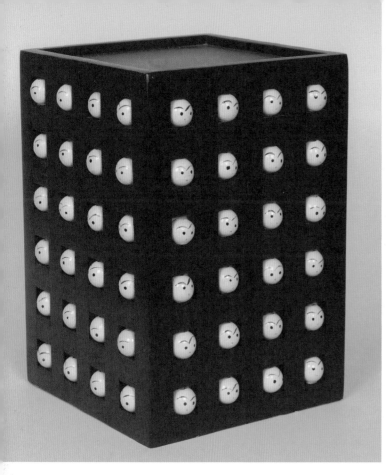

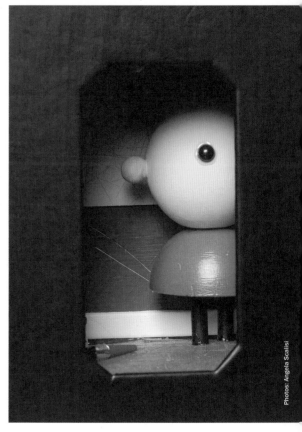

LEFT:
96 Heads, 2007.

RIGHT:
The Artist in His Studio, 2007.

——

PREVIOUS PAGE:
96 Heads (detail), 2007.

Photo: Andy Burkholder

DURING THE SUMMER and autumn of 2007, I became severely depressed and found myself unable to draw. In order to (a) keep my hands busy and (b) avoid going insane, I decided to start making some three-dimensional objects (I hesitate to call them sculptures).

96 Heads is made out of a napkin holder I spray-painted black, and a bag of identical doll heads I ordered from a "hobbies and crafts" website. Because the doll heads were hand-painted—and let's be thankful we don't have that particular job—each one was actually slightly different. I liked the idea of 96 slightly different expressions, which inside a grid also start to resemble a narrative of shifting emotional states. The art of cartooning boils down to controlling the emotional effects created by the resonance of minuscule shifts within a unified system of mark-making.

The Artist in His Studio nakedly symbolizes my mental state during that period, although at the time I was mostly trying to ease my mind about the daunting prospect of purchasing a house. I built a miniature room, to demystify things like wiring and floorboards and to solve the eternal puzzle, "What is the purpose of baseboards and crown molding?"

The little man in the room is actually a damaged piece of wood from my friend Chris Ware's "discard pile" in his wood shop. I added legs and an eyeball and repainted it. The rest of the object is made of cardboard and other kinds of paper, not counting the paint, light bulb, brush bristles, tin foil, and a small piece of wood for the ink bottle and the brush itself. This object, like *96 Heads*, is less than seven inches tall.

My next "3D" project was also born of dysthymia. When I feel too paralyzed to draw, one strategy I have is to doodle Mickey Mouse over and over. My "style" ends up distorting him quite severely, and I decided to transfer my wonky 2D take on the character into a 3D design. This turned out to be neither simple nor obvious and was fraught with pitfalls, but I gained a new appreciation for the concepts of proportion and balance.

An aside: probably the strangest thing about Mickey Mouse is his ears, which are plausible as disks on a two-dimensional plane but make no sense in three dimensions. I read somewhere that the Disney animators in the 1930s tried to address this conundrum and started drawing Mickey's ears in one-point perspective, but this "realistic" approach only frightened the children.

The Artist in His Studio
(detail), 2007.

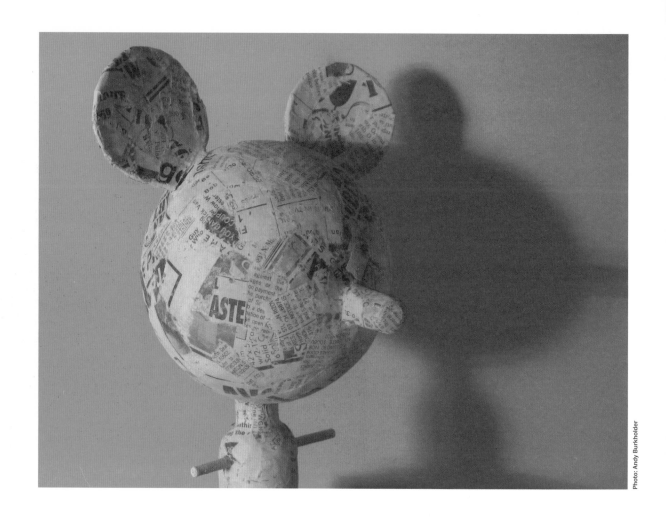

Distorted Mickey (in progress), 2009.
A papier-mâché project, shown here while still in progress.

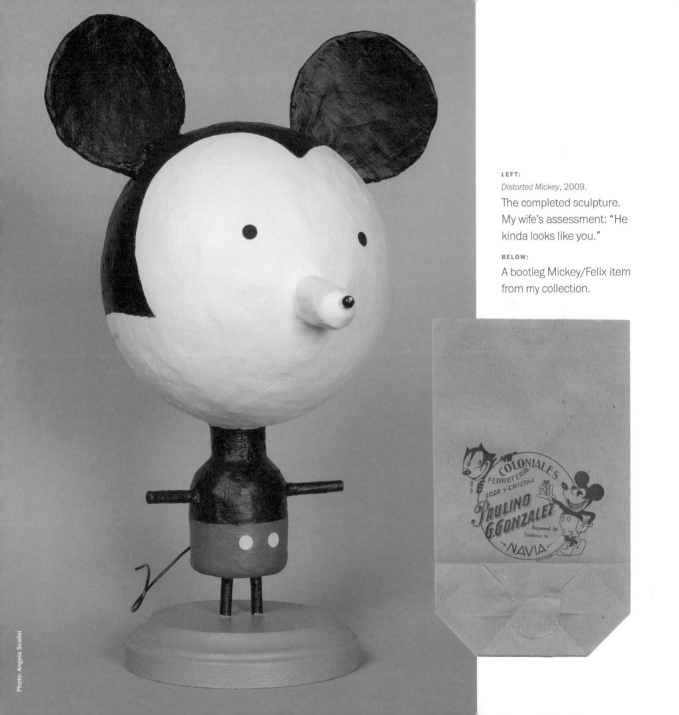

LEFT:

Distorted Mickey, 2009. The completed sculpture. My wife's assessment: "He kinda looks like you."

BELOW:

A bootleg Mickey/Felix item from my collection.

COLONIALES
FERRETERIA
LOZA Y CRISTAL
PAULINO
G. GONZALEZ
Regueral 26
Teléfono 56
NAVIA

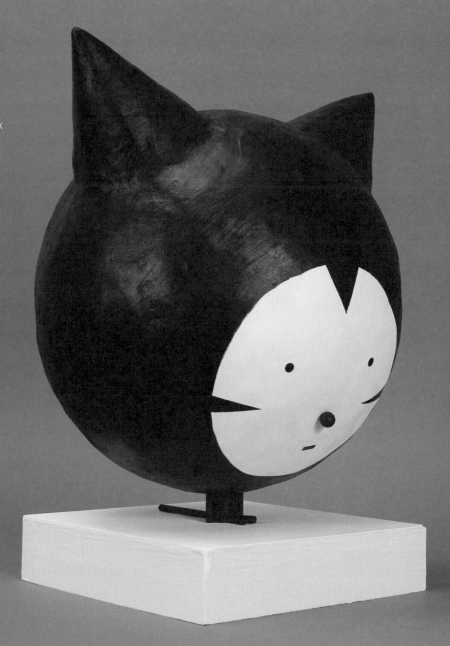

THIS PAGE:
Felix, 2012.

If Mickey Mouse's design is reminiscent of the Mandelbrot Set, then Felix the Cat may be more akin to the Koch Island. For years, I had several Felix-themed projects vaguely planned, resulting mostly in piles and piles of discarded Felix doodles. The less said, the better. Finally, the morass of false starts condensed and coalesced into this papier-mâché project.

FACING PAGE (RIGHT):
A bootleg Valentine's Day card from my collection of ephemera, featuring what appears to be an unintentionally disconcerting rendition of Felix.

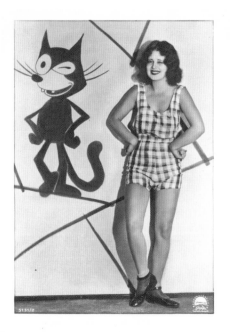

Clara Bow

„Ross" Verlag Reproduction verboten

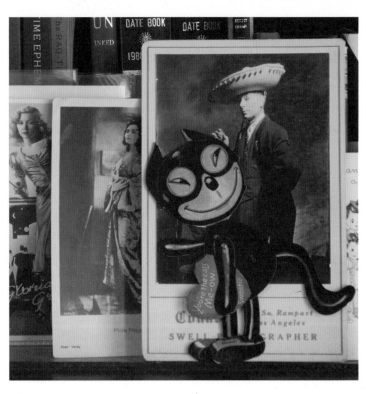

A CLARA BOW postcard, produced in Germany in the 1920s by the Ross Verlag. I have loved silent films since childhood, when I would watch old comedies every Saturday afternoon on Italian television. There was always a strong graphic quality to the costumes and even the faces of those old comedians.

Old film comedians can easily be reduced to small black-and-white doodles that manage to capture their essential gestures and costumes:

think of Charlie Chaplin's mustache and his bowler hat, too-tight jacket, baggy pants, and flexible cane; Buster Keaton's porkpie hat and stone face; Harold Lloyd's glasses and flailing limbs; Groucho Marx's mustache, glasses, and cigar, as well as his hunched, lascivious walk; the round vs. thin contrast of Laurel and Hardy; the distinctive hairstyles of the Three Stooges.

In my late 1970s childhood, here in America, I saw the same simple,

bold, and direct graphic qualities in Woody Allen's oversized head and thick-framed glasses, as well as Andy Kaufman's black dickey, checked sports jacket, and white flood-pants.

I suppose the intertwining of comedy and costume goes back to the *commedia dell'arte*, and likely even earlier. I'm sure there's an exhaustively researched and excruciatingly detailed Ph.D. dissertation about all this out there somewhere.

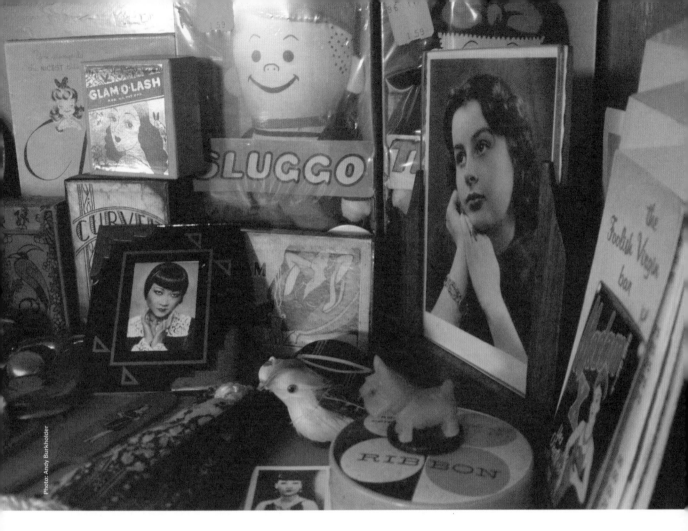

Photo: Andy Burkholder

ABOVE:
A portion of a shelf from one of my display cases. I collect a lot of flotsam and jetsam; I suppose the more useless the item is, the better.

FACING PAGE:
A decidedly non-erotic "pinup" girl (*Rose*) from Buenaventura Press's 2006 accordion book *Private Stash*.

Photo: Angela Scalisi

RIGHT:

Jean Seberg Doll, 2010.

This construction is about 9 inches tall, the wobbliness notwithstanding.

Forgive me if I sound like a doddering old fool, but I always thought the plot of *Breathless* was pretty dopey. The film truly comes alive only when Ms. Seberg graces the screen with her presence.

—

FACING PAGE:

Four Actresses, 2010.

CLOCKWISE, FROM TOP LEFT:

Liv Ullmann, Jeanne Moreau, Giulietta Masina, and Setsuko Hara. This is a very small digital print, magnified here to 1600% of its original size.

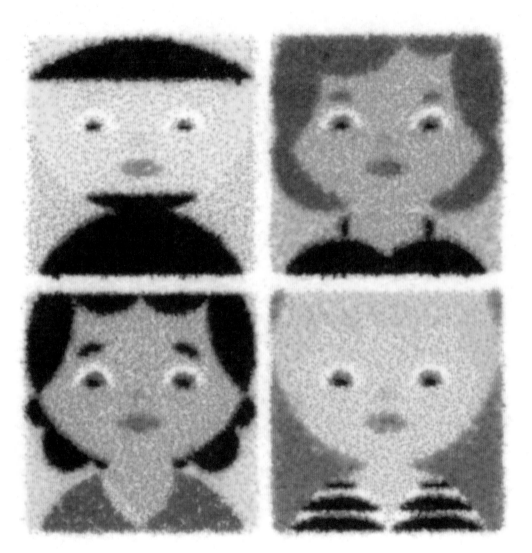

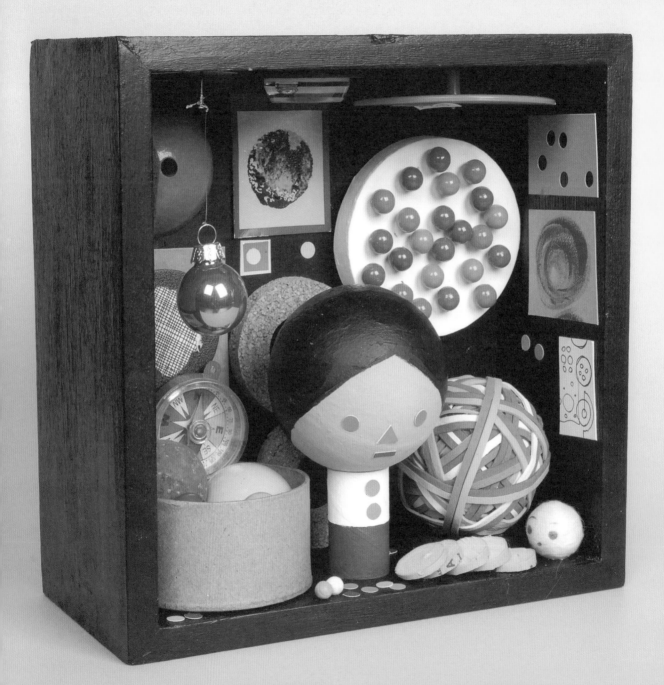

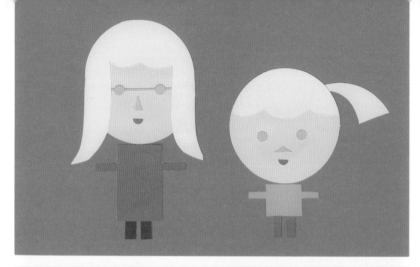

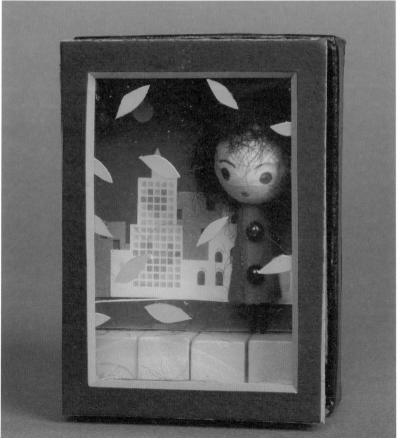

Maizie and Beatrice, 2011.

This is a paper cutout that I made to amuse my nieces. Children are the best audience, because their laughter is always genuine, perhaps because they have yet to be tainted by the matrix of lies that undergirds adulthood. If you find yourself horribly, miserably depressed, devoid of confidence and hope, I would advise you to make a quick, funny drawing as a gift for a little kid.

Teenage Laura, 2007.

Making a gift for someone is often the only motivator for me when I am in a slump. This small box (less than 4 inches tall) is a portrait of my wife as a high-schooler (hair inspired by Siouxsie Sioux). Unfortunately, this little whatchamacallit is starting to fall apart.

Artist, 2012.

This box is roughly 8 inches square and 3.5 inches deep.

LEFT:
Poster illustration for the 2009 Harold Washington Literary Award, sans the explanatory type that was added later by the designer. For the record, the award went to Dave Eggers that year.

FACING PAGE:
A Memory of Leslie Caron, 2009.

At one point I wanted to build a moving ballerina sculpture, loosely based on Leslie Caron's dancing in the 1955 film *The Glass Slipper* (an adaptation of the Cinderella story). Many years ago, I stumbled upon this film while numbly flipping through the television, and I was mesmerized by the mixture of intensity, defiance, longing, and self-absorption on her face and in her moves. I know nothing about ballet, but I know what I like.

The sculpture is beyond my abilities at this point, and all I have are quick sketches, as fleeting as my memories.

PAPERINA

Ivan .B.

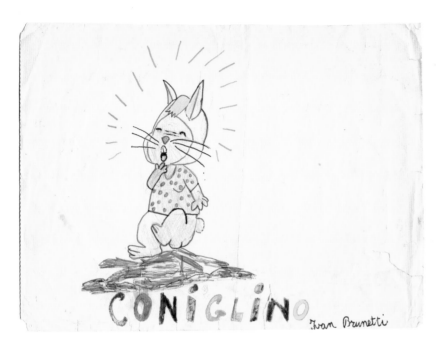

CONIGLINO *Ivan Brunetti*

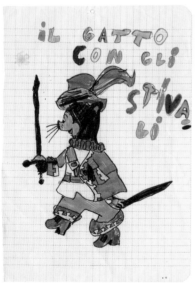

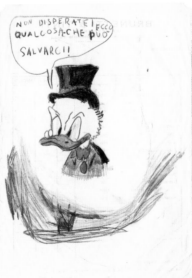

The drawings on these two pages and the following are but a few examples of childhood drawings (many, alas, have been lost or destroyed). They were done between the ages of four and six, circa 1971–1973. I consider this by far my best period as an artist. The drawings are careful, sincere, and free of pretension. If my house were to catch fire, the small box of my remaining childhood drawings is the only artwork of mine I would try to save.

———

PREVIOUS PAGE:
Paperina (i.e., Daisy Duck).

THIS PAGE:
Coniglino (i.e., Li'l Bunny).

Il Gatto con gli Stivali (i.e., Puss 'n Boots).

Non Disperate! (My rough translation: "Don't despair! Here's something that can save us!")

This is my first known drawing (around age 4). I recently dreamt that a younger alternative cartoonist whom I greatly admired had written a scathing review (in comics form) of my work. His cruel but accurate assessment: "Too much Disney."

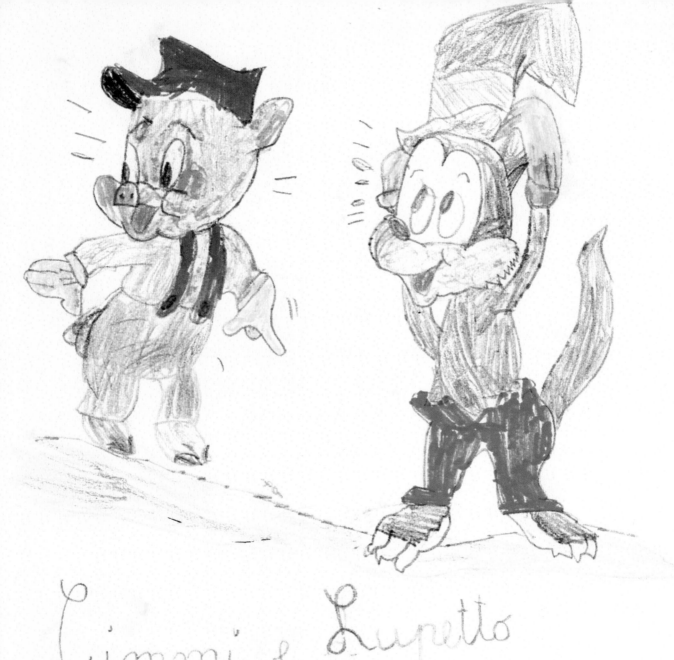

Gimmi e Lupetto

BRUNETTI & TINTI

PITTURE EDILI

Via Cappuccini – 61040 – *MONDAVIO* (Pesaro)

FATTURA N. _____ Li, _____

Spett. _____

DESCRIZIONE		Quantità	Prezzo	IMPORTO
Tinteggiatura tempera normale	mq.			
« « extra	mq.			
« lavabile normale	mq.			
« « extra	mq.			
Graffiato				
Buccia d'arancio	mq.			
Montaggio carta da parati	al rollo			
Verniciatura grondaie	ml.			
« infissi	mq.			
Scartavetratura	mq.			
Stuccature	mq.			
Montaggio cornici	ml.			
« rosoni in gesso	l'uno			
Bugnature	mq.			

Condizioni di pagamento: _____

All my earliest drawings were done on the reverse side of these unused invoices from my father's not-very-long-lived house-painting business, back when we lived in Italy.

—

FACING PAGE:
Gimmi e Lupetto
(i.e., Jimmy and Wolfy).

A childhood story (c. 1973)

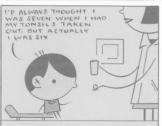

I'D ALWAYS THOUGHT I WAS SEVEN WHEN I HAD MY TONSILS TAKEN OUT, BUT ACTUALLY I WAS SIX

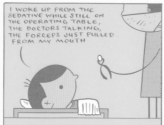

I WOKE UP FROM THE SEDATIVE WHILE STILL ON THE OPERATING TABLE, THE DOCTORS TALKING, THE FORCEPS JUST PULLED FROM MY MOUTH

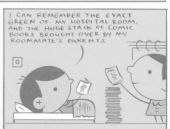

I CAN REMEMBER THE EXACT GREEN OF MY HOSPITAL ROOM, AND THE HUGE STACK OF COMIC BOOKS BROUGHT OVER BY MY ROOMMATE'S PARENTS

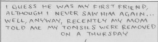
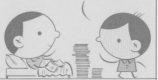

I GUESS HE WAS MY FIRST FRIEND, ALTHOUGH I NEVER SAW HIM AGAIN... WELL, ANYWAY, RECENTLY MY MOM TOLD ME MY TONSILS WERE REMOVED ON A THURSDAY

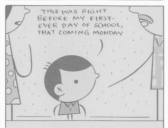

THIS WAS RIGHT BEFORE MY FIRST-EVER DAY OF SCHOOL, THAT COMING MONDAY

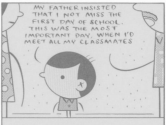

MY FATHER INSISTED THAT I NOT MISS THE FIRST DAY OF SCHOOL. THIS WAS THE MOST IMPORTANT DAY, WHEN I'D MEET ALL MY CLASSMATES

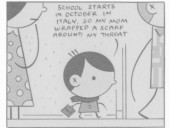

SCHOOL STARTS IN OCTOBER IN ITALY, SO MY MOM WRAPPED A SCARF AROUND MY THROAT

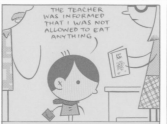

THE TEACHER WAS INFORMED THAT I WAS NOT ALLOWED TO EAT ANYTHING

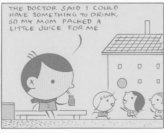

THE DOCTOR SAID I COULD HAVE SOMETHING TO DRINK, SO MY MOM PACKED A LITTLE JUICE FOR ME

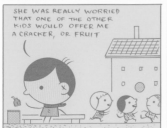

SHE WAS REALLY WORRIED THAT ONE OF THE OTHER KIDS WOULD OFFER ME A CRACKER, OR FRUIT

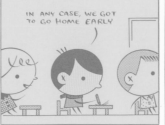

IN ANY CASE, WE GOT TO GO HOME EARLY

I HAVE ABSOLUTELY NO MEMORY OF MY FIRST DAY OF SCHOOL

BRUNETTI

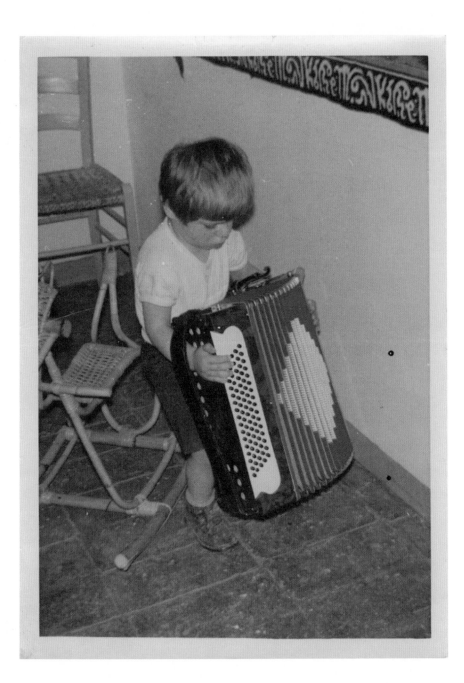

Photo of me with my father's accordion (c. 1970). As my mother theorizes, it is perhaps because I was *sempre molto serio e molto sensibile*, always very serious and very sensitive, as a child that I spent so many of my adult years sad and alone.

———

A Childhood Story (c. 1973).

Comic strip from the San Francisco *Panorama* (published by McSweeney's in January 2010).

Memory of My First Week in America, 2011.

When I was a child, my family moved from the sunny climes of a farm in central Italy to the bitterly cold climes of the Southeast Side of Chicago, Illinois, smack dab in the middle of what is now affectionately known as The Blizzard of '76. It was never adequately explained to me why we did this. I knew maybe two words of English, and I had never seen houses packed so close together before, or clusters of factories, or towering mountains of snow. It was like moving to another planet. I have never thought about it all that much, but the experience must have been somewhat traumatic, because ever since Chicago became my new home, I have been afraid to leave.

The box is 7 inches square and just over 3 inches deep.

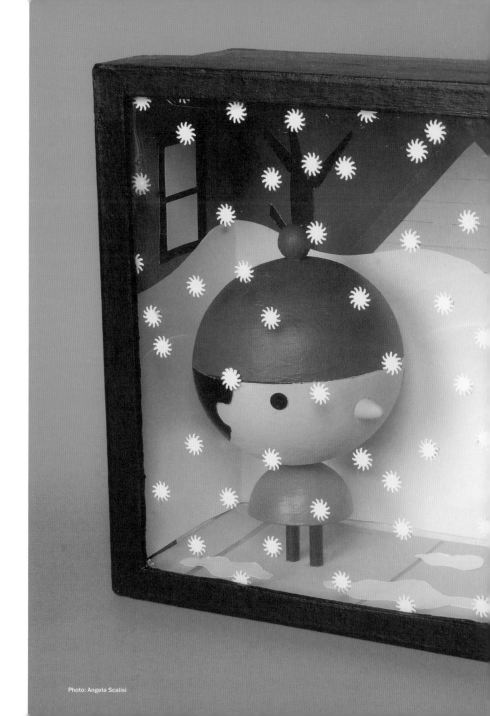

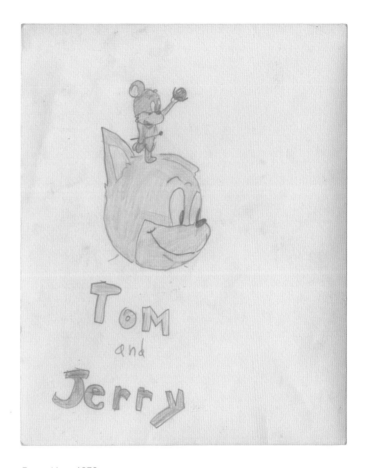

Tom and Jerry, 1976.

One of the earliest drawings I remember doing after I arrived in America (I can tell from the paper). I can also tell that already my drawings were starting to get worse.

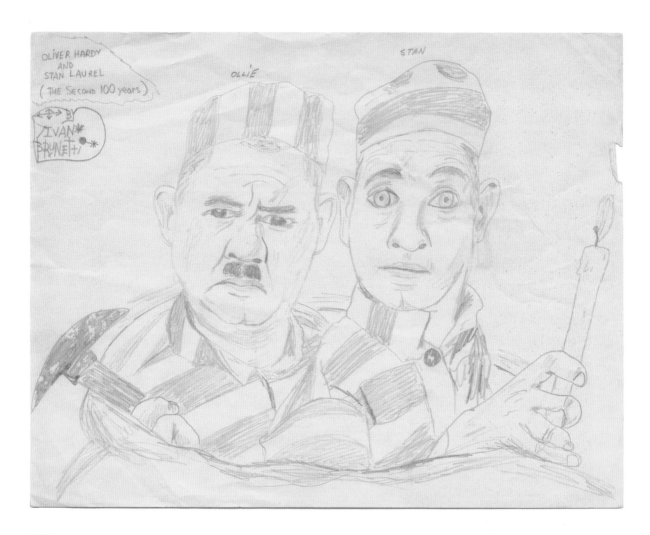

ABOVE:

Oliver Hardy and Stan Laurel, 1980.

Drawn around age 12. Like many a nerdy male of a particular stripe,
I was obsessed with old comedy, e.g., Charlie Chaplin, the Marx
Brothers, the Three Stooges, the *Honeymooners*, et al. Other childhood
obsessions, not pictured here: *Peanuts*, *Beetle Bailey*. Excessive
manliness in any form tended to frighten me.

FACING PAGE:

Dagwood and Blondie (detail), 1979.

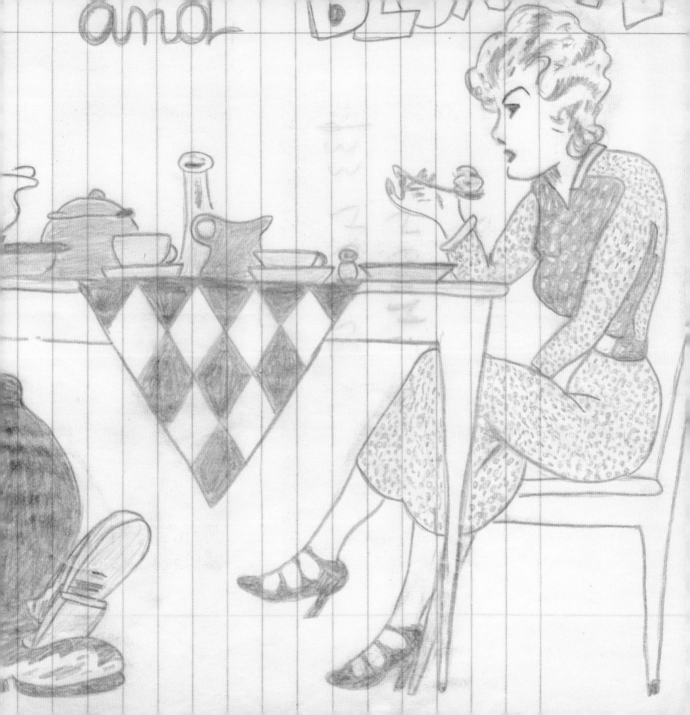

RIGHT:
Four Blurry Polaroids, 1998.

I thought I might try to create some sort of art project based on capturing an elusive moment (Betty Boop's hair cascading and uncurling). I never managed to complete (or even start) this project, the details of which I have long ago forgotten, but in any case the "elephantiasis of the head" aesthetic still permeates almost everything I do.

FACING PAGE:
Found photo of a parade, dated November 22, 1951. Photographer unknown.

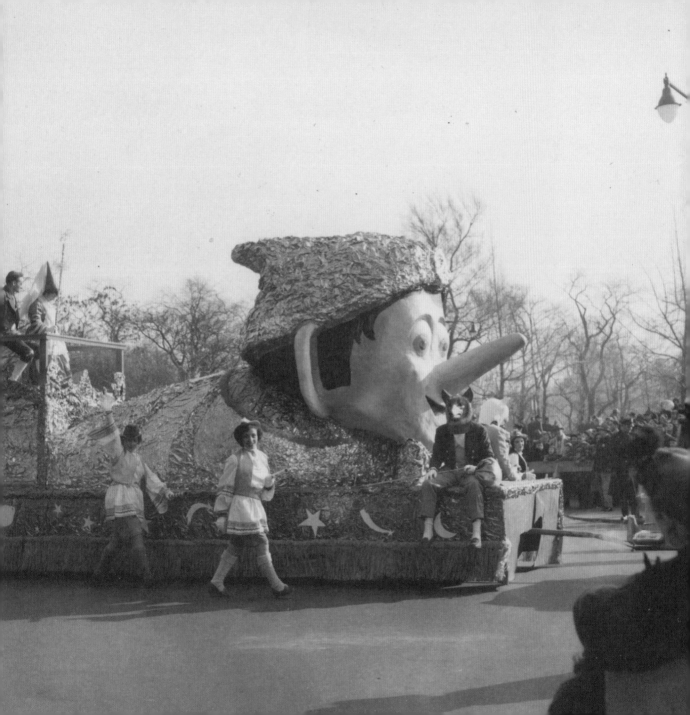

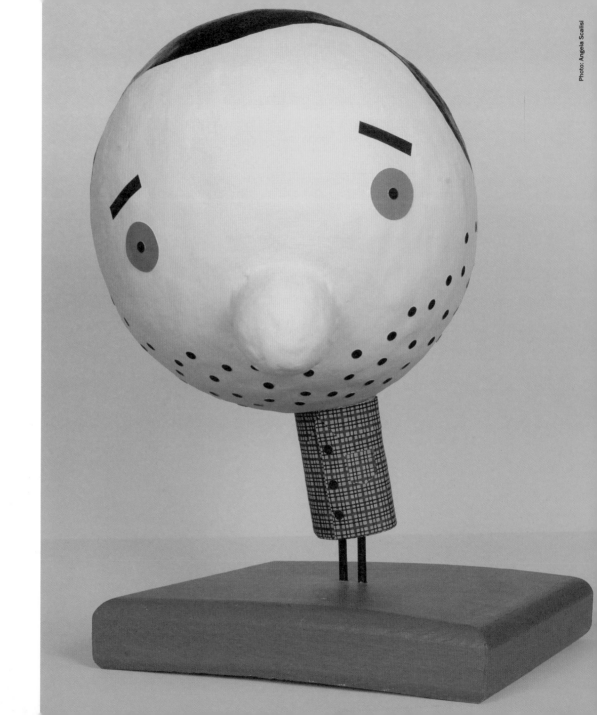

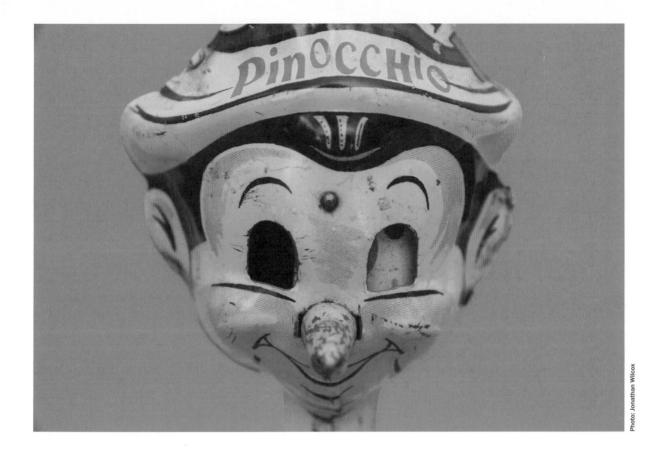

FACING PAGE:

The Leaning Tower of Ivan, 2011.

Part of my papier-mâché "art therapy" series, this self-portrait is about 16 inches tall. The teetering was unintentional, but fitting.

ABOVE AND FOLLOWING PAGE:

A small sampling of items from my Pinocchio collection. Every Italian boy grows up with Carlo Collodi's *Pinocchio*, and I was no exception. (I didn't see Disney's adaptation until I was 20 years old.) In the early 1970s, I saw a live-action version on Italian television—with an actual moving wooden puppet in the title role, which was somewhat disturbing. I remember lots of scenes enveloped in darkness. And rain. Lots and lots of rain.

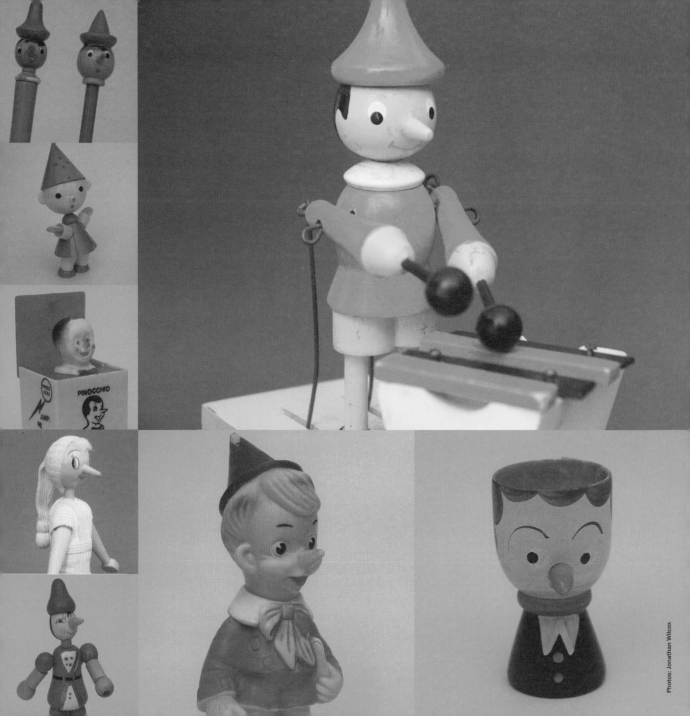

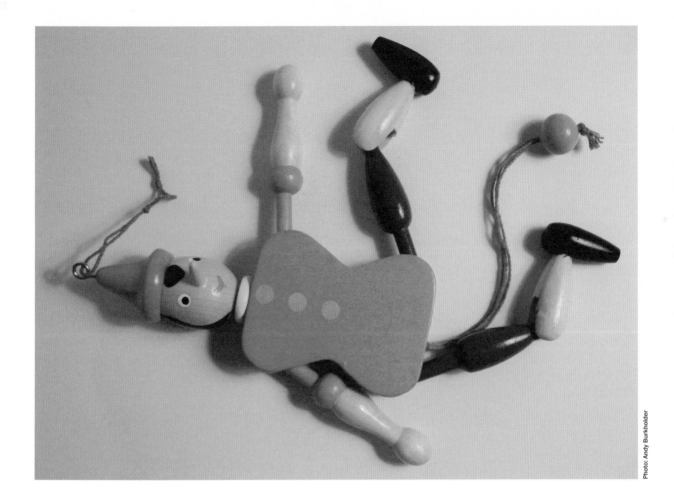

Photo: Andy Burkholder

ABOVE:

I found this Pinocchio toy a couple of years ago, and I must admit it cheers me up whenever I pull the string.

FOLLOWING TWO PAGES:

I collect toys, doo-dads, bric-a-brac, and other nonsense, and these sad, cute (but bordering on grotesque), often anonymous items inform much of my own cartooning. How can there be life behind those dead eyes? I suppose that's what every cartoonist is trying to create: something alive out of something inert.

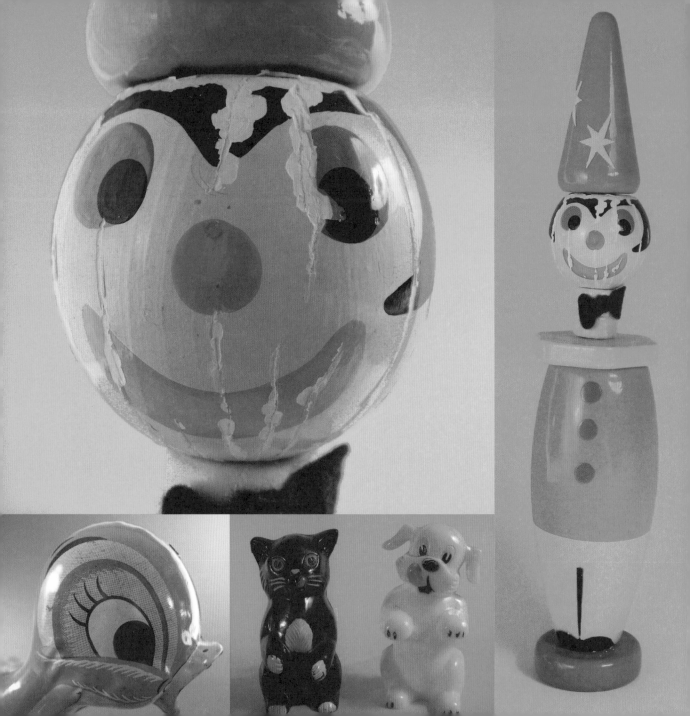

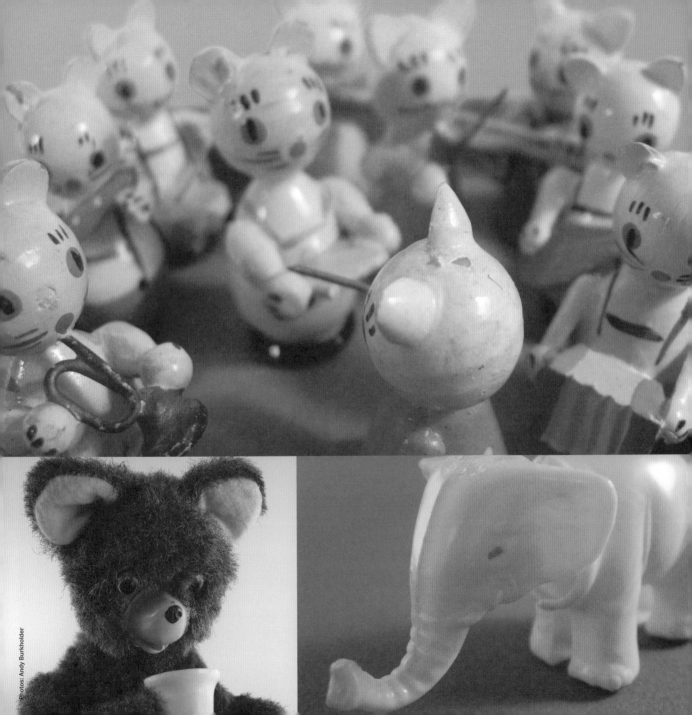

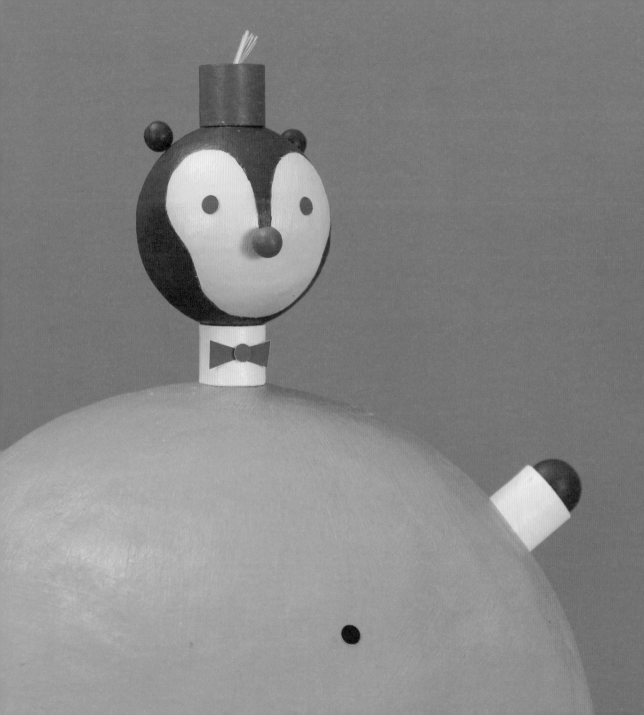

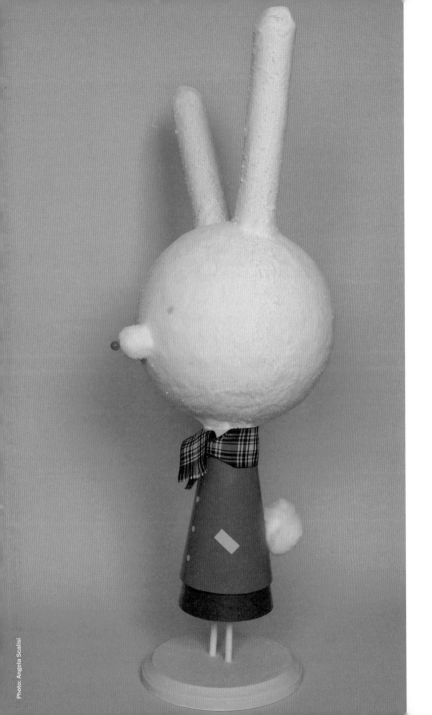

LEFT:
Rabbit, 2011.

This papier-mâché construction is approximately 25 inches tall.

When I was a child I had a toy bear that I hugged so fervently, all of its flocking was eventually rubbed off, leaving only a hollow, thin plastic shell.

—

FACING PAGE:
Bear (detail), 2012.

The full object (papier-mâché, cardboard, wood, acrylic) has a bottom half and is 16 inches tall.

SECOND PAGE FOLLOWING:
64 Cartoon Characters Doodled from Memory, 2003.

IVAN BRUNETTI

a brief biography

IVAN BRUNETTI WAS born in a small town in Italy on October 3, 1967. At the tender age of 8, he moved from his grandparents' farm in Italy to the industrial Southeast Side of Chicago; he has lived in this fair city ever since, rarely venturing outside of its bittersweet confines.

He has worked as a fast-food cook, dishwasher, political canvasser, telemarketer, parking-ticket giver-outer, truck-loader, information-desk guy at a hospital, technical draftsman, janitor, production assistant, proofreader, copyeditor, web designer, and college professor. Recently, he has taught at the University of Chicago, and he is currently a professor in the Art and Design Department of Columbia College Chicago.

In 2005, he curated *The Cartoonist's Eye* for the A+D Gallery of Columbia College Chicago; the exhibit was a preview for *An Anthology of Graphic Fiction, Cartoons, and True Stories* (Yale University Press, 2006), which he edited. A second volume of the *Anthology* was published in 2008.

In addition to the above, he has contributed sporadic comic strips to the *Chicago Reader* (and a handful of other alternative weekly newspapers) and has drawn comics and illustrations for the *New Yorker*, the *New York Times Magazine*, *Entertainment Weekly*, *Spin*, *Mother Jones*, *Fast Company*, the *Baffler*, the *Comics Journal*, *In These Times*, and (inexplicably) *Scooby-Doo*. His comics have been featured in *Kramers Ergot* Number 7, *McSweeney's* Number 13, and Houghton-Mifflin's *Best American Comics* 2006 and 2007.

To date, Fantagraphics Books has published four issues of his comic book series, *Schizo*, and a collection of inexcusable material, entitled *Ho! The Morally Questionable Cartoons of Ivan Brunetti*, which featured material from his out-of-print books, *Haw!* and its miniature companion, *Hee!* Moreover, in 2007 Fantagraphics published *Misery Loves Comedy*, which collected the first three issues of *Schizo* as well as a host of early and obscure work. The Ignatz Award–winning fourth issue of *Schizo* remains uncollected.

In 2007 Buenaventura Press published Mr. Brunetti's *Cartooning: Philosophy and Practice* booklet, included as a supplement to the magazine *Comic Art*. Yale University Press published a revised and expanded edition of this primer in 2011, which won a 2012 Eisner Award for Best Educational/Academic Work.

For more biographical information about Mr. Brunetti as well as his various "theories" about everything, please consult both his interview in issue 264 of the *Comics Journal* (Fantagraphics Books) and *In the Studio*, edited by Todd Hignite (Yale University Press, 2006).

Mr. Brunetti's comics have been translated into Spanish, Italian, Czech, Dutch, Swedish, Greek, and French.

He lives in Chicago with his wife and their two cats.

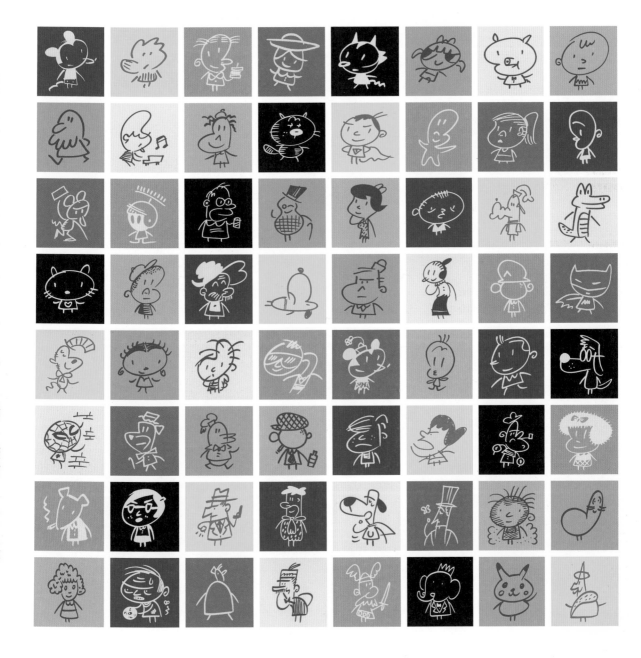